MURDER & MAYHEM
IN
SEATTLE

MURDER & MAYHEM
— IN —
SEATTLE

TERESA NORDHEIM

THE
History
PRESS

Published by The History Press
Charleston, SC
www.historypress.net

Front cover, bottom: Hotel Seattle, first home of the Seattle Public Library. *Seattle Public Library.*

First published 2016

Manufactured in the United States

ISBN 978.1.46713.660.0

Library of Congress Control Number: 2016944037

DEAD-ICATION

For Derrick

I feel like you are the reward for everything I've done right in my life.

CONTENTS

ACKNOWLEDGEMENTS

First and foremost, I would like to thank my fiancé and really, really, ridiculously delightful daughters for supporting my passion, forgiving me for the hours of neglect and moody moments and their never-ending words of encouragement. Derrick is my rock, and I dedicate this book to him. He stuck by my side every step of the way, no matter how many times I turned into an evil monster, and encouraged me to fight until the finish. Cindi and Katerina (aka K-Dragon) are my inspirations and motivation for continuing writing and to never give up, even when the rejection slips came in daily. I hope I've inspired them to follow their dreams, no matter how impossible they may seem.

Throughout the process of writing this book, many individuals from the community and dear friends have taken time out to help. I want to extend a thank-you to all of those remarkable people. My marvelous granddaughters, Kaeloni and Gillian, brought me smiles and joy during the most difficult moments with their mischievous mayhem. My parents allowed me to follow my ambitions and encouraged my creativity from a young age. Thank you to my cat, Freya, for her unconditional love and for waking me every time I fell asleep at the laptop. The Seattle Public Library donated the majority of the historical photos in this book, and my contact from there, Jade, made the process of obtaining photos easy as pie. My sister, Kari, has been a perfect friend and support system. Joe has guided me along the way and donated research and wisdom. Working with Ross on *Tacoma's Haunted History* opened many doors for me, and I will be forever grateful. Annie helped locate

interesting characters and really saved the day at the end of the process. Denielle, Melissa, Doug, Amanda, Christie, Cheri, Kim, Cristin, John and Dennis offered pep talks, which kept me motivated, and they all allowed me to vent on the stressful days. Without friends, I might be at Western State Hospital right now.

Last, but certainly not least, I would like to thank The History Press and the two best editors in the world, Christen and Megan. This book would never have come to life without their assistance. They went above and beyond to help me locate photos and meet my deadline. I will always treasure their contributions.

In memory of Dr. Bryan Whitemarsh: July 21, 1968–June 2, 2016.

1

INTRODUCTION TO SEATTLE

Controversy at Day One

Today, Seattle is known for Starbucks coffee, Boeing, Microsoft, the Space Needle, rainy weather, mountains, ocean beaches and Pike Place Market. At least, these are the items that the local travel agents might use to seduce people to the Emerald City. However, as with any other city in the world, there is a dark and more sinister side to Seattle—one that is often hidden not only from the public eye but from travelers and locals as well.

One of the first objectives of a new city is to establish law and order, for without it, chaos and malady will certainly follow. One of the ultimate criminal offenses is taking the life of another human. This is why society has rules and laws that carefully govern such an ominous wrongdoing. These laws provide guidelines for determining the severity, penalty and even classifications of killings.

Frequently, people interchange the terms murder and homicide, but there is a difference. Homicide is defined as an unlawful killing of another human being. Homicides are divided as criminal, excusable and justifiable. Murder is a form of criminal homicide in which the perpetrator intends to kill their victim, and it is sometimes premeditated. It is unjustifiable, and the consequences are severe. Excusable and justifiable homicide is a murder committed without criminal intent. Examples might mean the person was defending themselves or another person. It can also include law enforcement killing someone in the line of duty.

The most serious offense, murder, is divided into several different classifications depending on the severity and circumstances of the crime.

There is first degree, second degree and third degree, which is often called manslaughter. First degree is the most serious offense and is premeditated, or planned. In some states, first-degree murder charges can be brought into play when the death occurs during a different, preplanned crime, such as rape, arson, robbery or even kidnapping.

To be charged with first-degree murder in Washington, the murder itself must be willful and premeditated. In this case, the killer plans ahead and attacks the victim with the intent to take their life. If convicted, the murderer will not receive anything less than life in prison. It can be changed to aggravated murder if there are extenuating circumstances surrounding the murder. For example, the killing of a police officer could be a first-degree murder charge. For this charge, the killer can receive the death penalty. Serial killers usually have a clear plan for each of their victims. Gary Ridgway drove the streets looking for prostitutes to kill. He planned which streets to drive, which type of woman he was wanting and how he would kill them.

The next degree is second-degree murder, which is an intentional killing that is not premeditated or planned. This can occur when the murder happens and the killer intends to kill, but he didn't approach the victim with an intentional plan. An example might be a dispute between neighbors and a property line. The neighbors are discussing a solution but a gun is pulled; one neighbor is shot and killed. This could also occur if one neighbor grabbed a shovel and struck the other neighbor in the head. The strike to the head kills the neighbor. A clear example of this degree can be seen in riots that occurred in Seattle in 1999. A man struck another man on the head with a skateboard, which caused a fatal head injury.

Next in line is manslaughter, which can be either voluntary or involuntary. If the manslaughter is voluntary, then there was intent to kill, but original intent was only to harm a person. The main distinction between second-degree murder and manslaughter is the circumstances surrounding the case. It is often described as a heat-of-passion killing in which the defendant is provoked or angered, striking out in an attack that ends in death. This could be a bar fight that went wrong. One man intends to punch another man hoping to hurt the other person. However, the second man falls to the ground and dies. Involuntary manslaughter is still an unlawful killing, but the defendant did not premeditate the actual killing and may not have even intended to harm the other person. Involuntary manslaughter can be divided into two categories: constructive and criminally negligent. Constructive manslaughter is when, without malicious intent, a killing occurs as the result of a crime. For example, a speeding vehicle in a school zone strikes and kills a

child. The defendant broke the law by exceeding the speed limit but did not intend to kill the child. Driving under the influence of alcohol or drugs can lead to an automobile accident. If that accident involves another car, and the driver of the second car dies, the driver under the influence can be charged with manslaughter. Again, a drunk driver doesn't set out to kill anyone, but driving under the influence is illegal and the death occurred during the illegal offense. Criminally negligent means the defendant committed a serious crime that resulted in death to the victim. This could happen in a hospital when a doctor fails to notices a patient's oxygen tank has disconnected from the supply and the patient dies. Vehicular manslaughter is the charge for a drunk driver who kills someone while driving under the influence of alcohol.

The death penalty is legal execution of a criminal who has committed a serious offense. It is often referred to as capital punishment and varies from state to state. In the state of Washington, a total of 101 executions have been carried out since 1849. The most popular method is hanging, followed by lethal injection. In Washington, convicted murderers' first choice for the death penalty is death by lethal injection. However, if the convicted murderer chooses hanging, the state must oblige. As of 2015, the Washington State Penitentiary in Walla Walla lists nine men on death row, and one of them, Robert Yates, is featured in this book. Others featured in this book have been executed for their crimes, including James Champoux, James Mahoney, Wallace Gaines, Jake Bird and Westley Dodd. Ted Bundy was executed in Florida. Gary Ridgeway lives at the state penitentiary in Walla Walla but is serving a life sentence rather than a death sentence. Currently, the state has a moratorium on execution.

Comparing the population to the death rate for both the early 1900s and present-day Seattle proves there have always been problems with this particular crime within the city and the surrounding area. In fact, it's not unusual for a larger city to struggle with murder and mayhem.

Another contemplative term is massacre. Mass murder is just as it sounds. It is the slaughtering of several victims at the same time. The actual event of mass murder is referred to as a massacre. Unfortunately, Seattle has seen at least two of this style of murder. At the Wah Mee Club, on February 18, 1983, fourteen people were shot down, and thirteen died. Crime scene photos detail a graphic bloodshed and multiple victims lying down on the ground, hogtied and helpless. The Capitol Hill area had a similar incident when a man attending a local party with mixed company decided to turn the night deadly. He killed six people and injured two more before turning the gun on himself, dislodging brain matter from his skull.

The first documented murder in the United States came in 1630. John Billington, one of the original Plymouth colonists and signer of the Mayflower Compact, had the dubious honor of being the first convicted murderer. He would hang via a noose for his crime and also be the first man to be executed for his crime in this country. These aren't the type of firsts that make parents proud.

While murder and mayhem most likely took place in the Seattle area long before the white settlers arrived, those stories remain hidden among the shadows of the dark tales that followed.

Agnew's Saloon in Renton, Washington, accommodated an unforeseen bar fight on February 4, 1877. Soloman Baxter attempted to break up an altercation between John Thompson and another man. Thompson stabbed Baxter in the stomach, causing injuries that would send him to the local hospital. Despite receiving medical attention, Baxter died the following day.

Thompson faced a trial by a jury of his peers and was found guilty of murder on September 28, 1877. This would mark possibly the first murder on record for King County and definitely the first legal execution. The King County sheriff played executioner on the day Thompson swung from the gallows.

Washington's territorial legislature enacted the death penalty in 1854. At the time, hangings could take place anywhere there were gallows. By 1901, stricter rules had been set, and all executions were required to take place at Washington State Penitentiary in Walla Walla. Since that time, many executions have taken place at the penitentiary.

Zenon James Champoux was hanged at the penitentiary on May 6, 1904, for the murder of eighteen-year-old entertainer Lottie Brace. Brace promised to marry Champoux, but then she found employment in the oldest occupation: prostitution. When Champoux found Brace and she refused his advances, he drove a knife into her temple. She died later that day.

Champoux would offer a plea of insanity, but the judge sentenced him to death. His prison stripes were traded for a black suit, and the priest arrived to offer a prayer before Champoux was escorted to the gallows. With no words and a single tear falling from his cheek, Champoux was pronounced dead at the age of twenty-eight, almost instantly after he dropped. His heart would continue to beat for an additional seventeen minutes. Zenon James Champoux was the first to be executed in the state prison in Walla Walla, Washington. He was also the first King County resident to be executed.

Washington would abolish the death penalty in 1913 but enact it again in 1919. Since 1904, there have been seventy-eight executions in Washington

State. Several of the men mentioned in this book are included on the list of individuals who met their death via execution in Washington State.

Now death, murder and mayhem haven't always been present in Seattle. However, controversy sits as deeply as the establishment of the city. All accounts agree that George Vancouver was the first European explorer to reach the Puget Sound. He arrived while serving with the British navy and in command of the expedition to the North Pacific. In 1792, he arrived at the Puget Sound. He dropped anchor between Blake and Bainbridge Islands before swiftly naming over seventy-five landmarks, including mountains, islands, towns and a waterway. Most were named for members of Vancouver's crew, as well as friends and colleagues. His mission was to survey and map the lands, not conquer the natives or build a new city.

As for the city of Seattle and the surrounding area, there are at least two well-known versions of the story of its history. Two very different men came to the area with the same final goal: they wanted to build a thriving city near the Puget Sound. Both men are noted in the history books as vital characters in the building of Seattle. However, they were polar opposites, and in the end, the one who was the most publicly acceptable ended up with the most notoriety. The two men would become rivals but partners as well. For without one, the other may not have brought the missing ingredients to Seattle.

The first of the men is Arthur Denny, who was born near Salem, Indiana, in 1822. In 1851, at the age of twenty-nine, he would arrive at the Puget Sound and begin leaving his mark. He was a political conservative and devout Christian. He was so opposed to drinking alcohol that he would refuse service in his store to customers who had partaken in the evil spirits. When Denny wrote in his biography that his trip to the Puget Sound was a "desperate venture," he was right on the mark. To all those who knew Denny, this trip was completely out of character. He would rather be a cool, smooth businessman and investor then a risk-taker.

As cliché as it sounds, it was a dark and stormy night in November when Arthur Denny and his wagon party arrived at Alki Beach in 1851. The rain was coming down by the bucketful, which isn't unusual for Seattle, but it did make settling in difficult for the weary travelers. Dim, gloomy skies darkened the night, making it difficult to navigate through the Duwamish Bay, which was already struggling with its own turmoil from the wind.

The journey presented many dangers along the way and obstacles to cross. The troubles would not vanish when they reached the Washington Territory. In fact, struggles with weather, fights over land and even a fight to be the

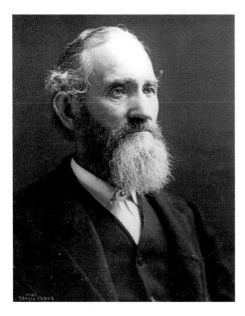

Arthur Armstrong Denny, portrait by Asahel Curtis. *Seattle Public Library.*

first would meet the Denny party head on, but they fought their way through. Acquiring necessities like food and shelter were nearly impossible feats. Illness was common, and Denny himself was said to be sick through the entire trip.

They battled Native Americans along the way but escaped without harm. They rested in late August 1851 in Portland, Oregon, where Mary, Denny's wife, gave birth to their son, Rolland Denny, on September 2, 1851. David Denny, Arthur's brother, would forge forward toward the Puget Sound with John Low and Lee Terry, while the others stayed behind.

He staked the claim on an unfinished cabin near present-day Tumwater, Washington, and sent Low back to Portland to alert the others while he worked on the cabin. The older people of the group would stay behind in Portland, while Arthur and the rest of the party would travel on to the Puget Sound, not arriving until November 13, 1851.

On the morning of November 13, they arrived at Alki to find an utter mess: David Denny recovering from an axe wound and Lee Terry missing. The cabins in which they were to stay were mere unfinished shacks. There was an immediate concern for offering suitable housing for the women and children in the party. Other settlers had already staked a claim on Alki. Arthur Denny was greeted by his brother's words: "You shouldn't have come."

Denny was a fighter and determined to make it work in the new area. Though discouraged, he didn't halt the plan he had already been putting into action long before he reached the Puget Sound. Thankfully, they would find some help along the way.

They were greeted by Chief Sealth, a Duwamish chief, and his tribe six weeks later. Chief Sealth would become known as Chief Seattle by the white settlers, as they had trouble properly pronouncing his first name. The chief held a high honor among his tribe and strived to create a lasting bond between the natives and the new visitors. Unlike other natives around

the United States and in the Northwest, Chief Seattle knew a civil and friendly relationship with the new settlers was important to keep his people safe and sound.

The women and children of the Denny party stayed at the beach while they waited for proper housing to be established farther inland. Arthur and the other men didn't like the site or the cabins. With help from the Duwamish tribe, Chief Seattle assisted the Denny party in building cabins to help stave off the wet, freezing Washington winter and provide safety to the men, women and children.

Denny and his party were not the first to settle in this area. Others had moved to the Northwest for fishing and logging, and some even came for gold. Some came to claim land and build farms. However, Denny had a very different purpose. Denny came to build a new city.

The Dennys moved to the west side of the bay, while Terry and Low stayed at Alki. The name Alki came from Terry's hometown in New York State. Henry Yesler was invited to Alki to operate his steam-powered sawmill,

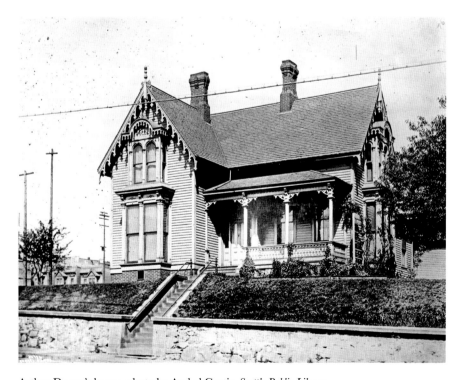

Arthur Denny's house, photo by Asahel Curtis. *Seattle Public Library*.

which would make ample money and facilitate growth for the growing town. One by one and task by task, Denny would help bring many of the needed ingredients to the table to start building the city.

Seattle would become the name of the city in honor of the great chief who provided so much help to their endeavor. The credit for the naming went to Denny's rival, David Maynard, who was a doctor by trade but also came to the Puget Sound to build a city. Maynard instantly made friends with the Native American tribes, and when Chief Seattle asked him to move his general store to the village of the Duwamish, Maynard eagerly agreed. He also renamed his store the Seattle Exchange. This paved the way for the naming of the city.

Maynard is the other key player in the founding of Seattle. He is a man sometimes hidden from the public eye. David Maynard, better known as Doc Maynard, was born in 1808 in Castleton, Vermont. Maynard put his medical training to use while traveling over to the Puget Sound area via wagon trail. His kind heart and nature to heal made him different than some doctors on the trail, who feared catching disease from the ill. He was known to be a heavy drinker and enjoyed a visit to the local brothels, even when he was a married man. Maynard often visited Seattle's infamous Madam Damnable at her brothel. One of his strongest qualities was his likable character and ability to advocate for the natives. This would pay off when he arrived in Washington and greeted the natives.

As he made his way west, Maynard made many stops to help care for sick travelers. When one leader of a small wagon train died, Maynard stepped up as the new leader. When he left his Ohio home in 1850, he left behind his wife, Lydia; daughter, Frances; and son, Henry. It is not known if he intended to send for them once he settled in the West or if he had intended to allow his wife to file for divorce based on his abandonment. Either way, Lydia didn't file for divorce, and Maynard didn't send for his family. Instead, he met a widow along the way by the name of Catherine, and the couple fell head-over-heels in love. Initially, her brother refused to permit them to marry; he probably had the right idea.

Upon reaching Alki, Maynard quickly found his place in the logging activities. While others were selling their wood to shippers, Maynard leased a boat and took the wood to San Francisco himself. Cutting out the middleman would make a tenfold profit that jingled nicely in Maynard's pocket. Washington had what seemed to be an endless supply of wood, and San Francisco was not only a growing town, but also one that kept burning to the ground. Therefore, its residents were in constant need of Washington timber.

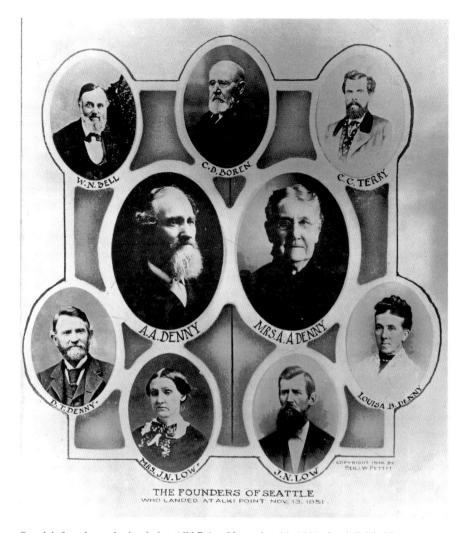

THE FOUNDERS OF SEATTLE
WHO LANDED AT ALKI POINT NOV. 13, 1851.

Seattle's founders, who landed at Alki Point, November 13, 1851. *Seattle Public Library.*

Maynard used the wood and money earned to build a store that would compete with the only other one of its kind. The other store was owned by Catherine's brother, who swiftly agreed to a marriage between Maynard and his sister. The marriage would be contingent upon Maynard moving his store to Duwamish, which pleased Chief Seattle. Maynard also needed to make his divorce from Lydia official. The second task would take a little more charm and persuasion. Maynard's political skills were needed to persuade Oregon Territory to agree to a separation from Washington

Territory in exchange for a bill that granted him a divorce. Maynard would marry Catherine on January 15, 1853.

Denny, Maynard and the settlers were now all in place, and the mayhem was about to begin. Maynard wanted a section of land that belonged to Carson Boren. When Boren was out of town, Denny adjusted the claim to make room for Maynard. Before long, Boren, Henry Yesler, the Denny brothers and Maynard were platting streets and arguing over which direction the roads should go. In the end, Maynard won this battle, but some of the mixed-up streets that still exist in Seattle can be blamed on the early settlers and all of their disagreement.

Maynard was older than the other settlers and had assisted in building a city prior to Seattle. While Denny was building homes, Maynard obtained the rights to put a post office in his store, which would allow mail to be sent to Seattle. He sold plots of land cheaply to anyone who was willing to build a store or business that would contribute to the city's welfare. Each purchaser had ninety days to build and open their business before Maynard would repossess the land. This brought in a blacksmith, as well as many other vital businesses.

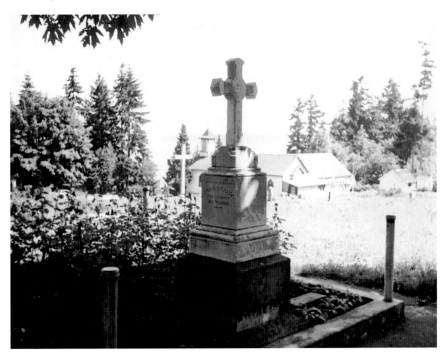

Grave site of Chief Seattle. *Washington State Digital Archives.*

The logging town was still missing one key player: a lumber mill. Maynard convinced Henry Yesler to set up a steam-powered sawmill on a section of land from Maynard and part from Boren. Yesler's sawmill would establish an economic structure for the city. The mill sat on a pier at the foot of what is now Yesler's Way. It was originally called Mill Street and then Skid Road.

Maynard came to Seattle as a doctor but studied and took on many other roles. He would become the first justice of the peace. When the only lawyer in town died, he studied law and passed the bar. He and Catherine opened a two-room hospital that welcomed both whites and Native Americans.

Maynard's connection with Chief Seattle and the Native Americans would lead to his appointment as the person in command of Native American relations. He would protect them during the coming war.

THE BATTLE OF SEATTLE

Natives Versus Settlers

Archaeologists believe today's Native Americans entered North America on a land bridge from Siberia to Alaska, exposed by lowered sea levels during the last ice age. Thus, the tribes of Puget Sound arrived here eleven or twelve thousand years ago, as glaciers receded.

Last to arrive to Washington was the U.S. military. Isaac Stevens was named the first governor of the newly created Washington Territory. However, that wasn't his only title. They also needed someone to help with the relations with the Native Americans. Therefore, Stevens was also named superintendent of Indian Affairs.

The U.S. military formed many treaties with the Native Americans. The tribes reluctantly gave the military land, and in exchange, they were given rights to fish, money, provisions and reserved areas of land where white settlers would not be permitted. Several small battles grew until they formed a war in Seattle between the military and the Native Americans. This was the first true battle between the two forces.

The Yakima War conflict took place between the United States and the Yakama tribe between 1855 and 1858. Andrew Bolon was an agent for the Bureau of Indian Affairs, assigned by Governor Stevens to the Yakama tribe. Bolon spent the summer of 1855 getting acquainted with the tribal leaders and familiarizing himself with the land. Many of the Native Americans felt the oversight of the white settlers was degrading and unjustified. Although they were unhappy with the treaties being presented, they did agree there would not be a war unless they were attacked.

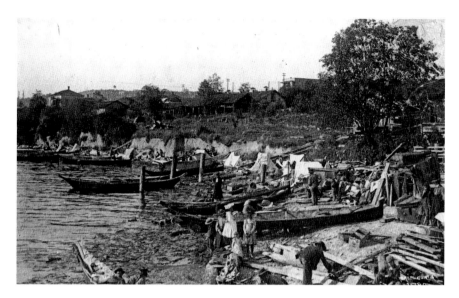

Native Americans at Belltown. *Seattle Public Library.*

The discovery of gold in Yakama territory prompted an influx of prospectors. This would only add to the tension that was already building. The prospectors crowded and invaded the space belonging to the Yakama tribe, and this did not please their leader, Kamiakin. Yet the tribal leader stood by his word of holding back an attack. This promise became harder and harder to keep when the prospectors began terrorizing the tribal men and women. One of the women was a disabled daughter of Chief Teias.

When Kamiakin's nephew Qualchan heard about a group of prospectors that had been attacking and raping women, including Chief Teias's daughter, he planned an attack. They ambushed six miners as they entered the Yakima River and killed them.

Rumors of the killings reached Bolon, and he left his post immediately to investigate. When he reached the area, Shumaway, brother to Kamiakin, advised his friend to turn back, as Qualchan posed a serious threat. Bolon heeded the word of the wise leader and chose to leave the area. He wouldn't get far before reaching Shumaway's son Mosheel and a group of tribal members heading to the falls to retrieve dried salmon. The story has been confused a bit over the years, and no one is certain what sparked Mosheel to take the steps he would against Bolon. Some say Mosheel was angered that Bolon had played a role in the execution of a relative during a previous war and sought revenge. Others say he was jealous of Qualchan's status for

taking the lives of six white prospectors. A final version alleges he knew Bolon would return to the white settlers with news of the killings and preventing his return would delay a war. Whatever the reason, Mosheel began convincing the other tribal members to help him kill Bolon. Since they were speaking in a dialect that Bolon didn't understand, they were able to plan his death while he rode quietly next to them on the trail. When they rested near a creek and warmed themselves by a small fire, the tribe members sprang into action, grabbing Bolon from behind. Bolon cried out in Chinook, the only dialect he knew, but it didn't stop Mosheel from killing Bolon without hesitation. They buried his body and left him behind. Mosheel would face the wrath of his father when he returned.

When Shumaway learned of Bolon's slaughter, he spoke with the other chiefs, suggesting all of the killers, including his own son, be turned over to the white settlers. The other chiefs refused. Shumaway sent a woman to relay the news of Bolon's death to his men at the camp. The military response started what was known as the Yakama, or Yakima, War. The war was lopsided. Yakama chief Kamiakin had a team of three hundred warriors. The military had only eighty-four in the troop.

The casualties were low after the first battle. The Native Americans lost three members: two killed and one captured. An additional four were injured. The military reported five dead and seventeen wounded. After

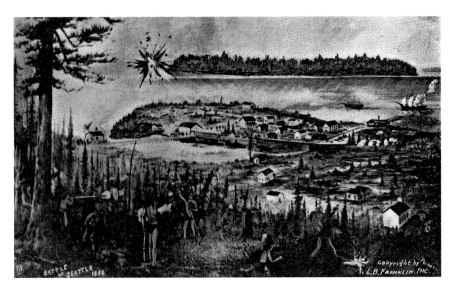

Attack by Native Americans, painting by Emily Inez Denny. *Seattle Public Library.*

a short retreat, the military would return with seven hundred troops to challenge the Yakama tribe. Before long, the Native Americans were surrounded. Qualchan was executed and Mosheel shot while trying to escape. This sparked two additional wars that would ripple through the Seattle area.

The Puget Sound War took place between 1855 and 1856, an armed conflict between the military and the Native Americans. The Battle of Seattle took place on January 26, 1856, as the Native Americans attacked the city of Seattle. To many, the distinction between the two battles is thin.

The Puget Sound War began over land rights, and the main catalyst was the Treaty of Medicine Creek. Nine Native American tribes—Nisqually, Puyallup, Steilacoom, Squawskin, S'Homamish, Stehchass, T'Peekskin, Squi-alitl and Sa-heh-wasmish—banded against white settlers and the military. The treaty at Medicine Creek was officially signed on December 26, 1854, by Governor Isaac Stevens, chiefs, headmen and delegate tribes. The signing took place at McAllister Creek by a single Douglas fir tree. This tree would become known as the treaty tree. The treaty granted 2.24 million acres of land to the United States in exchange for three reservations; cash payments, which would be granted over a twenty-year period; as well as hunting and fishing rights. It appeared to be a fair deal for everyone involved, if the Native Americans overlooked the fact that the land was theirs long before the white settlers arrived. Luckily, the representative from the Native American side did take this into consideration.

Chief Leschi, of the Nisqually tribe, was chosen to meet with Stevens and negotiate the details of the treaty. Leschi felt the treaty would take away several acres of prime farming land from the Native Americans. Outraged by the unfair deal the natives were being offered, Leschi chose to go to war and fight for their rights. Historians maintain Leschi refused to sign the treaty, and others suggest his signature was forged with an *X* or he was forced to sign under duress.

The fight began in October 1855. Chief Leschi traveled to Olympia to protest the terms of the treaty. Upon leaving the governor's office, the acting governor ordered Leschi and his brother to be tracked down and taken into custody. Thus, the war began.

Leschi took charge as the war chief, presiding over three hundred men and leading them in small raids against the white settlers. Early in the war, two military men, Joseph Miller and Abram Benton, were killed. The killing of two U.S. soldiers by Native Americans was not taken lightly. Leschi was held guilty of murder, regardless of whether he took the lives of the military

men or a member of his tribe did. Governor Stevens immediately sent troops after Leschi, demanding he be brought back to Olympia.

Troops captured Chief Leschi in November 1856. His brother would turn himself in a day later but was killed by an unnamed assailant. Leschi would face a trial for the murders and plead not guilty. During the first trial, the judge stated that killing an enemy solider during a time of war was not murder. This confused the jury and led to a hung jury. The second trial would hold a grimmer fate for the Nisqually chief, as this jury was not informed of the wartime rule. The jury deemed

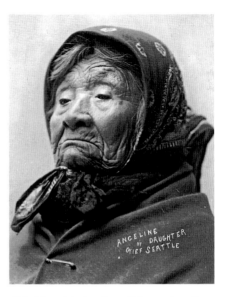

Chief Seattle's daughter, Princess Angeline. *Seattle Public Library.*

Chief Leschi guilty of murder and sentenced him to death. Outraged by the verdict, Leschi supporters continued to grow in number. An army soldier wrote two articles for the newspaper defending the chief. Ezra Meeker, founder of the city of Puyallup, Washington, was one of the jurors from the first trial who voted for an acquittal.

Regardless of the outcry from both white settlers and Native Americans, Leschi was scheduled to be hanged on January 22, 1858. A slight delay occurred when the Pierce County sheriff, George Williams, allowed himself to be arrested rather than carry out the execution. However, in a small valley near Lake Steilacoom, gallows were thrown together, and on February 19, 1858, Chief Leschi was hanged by noose until the life force was taken from his body.

Determined to prove Chief Leschi's innocence, his case was reopened in 2004. Both houses in the state legislature passed resolutions stating Leschi was wrongfully convicted and executed. They overturned his conviction. By unanimous vote, he was exonerated by the historical courts.

The 2004 hearings would come too late. On January 26, 1856, the Native Americans forged an attack on the city of Seattle. The settlers would only lose two people, but the Native Americans were estimated to have lost around twenty-eight and over eighty wounded. The battle would last only one day.

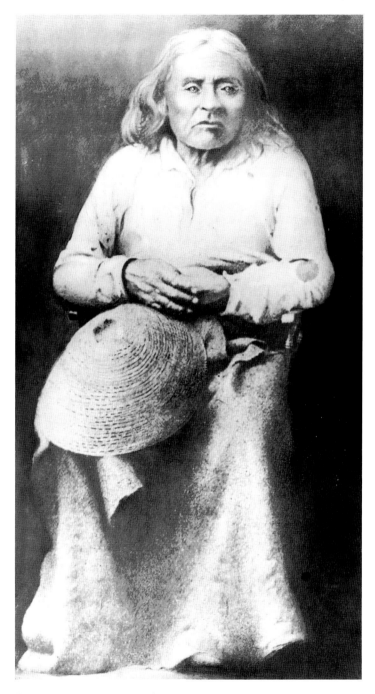

Chief Seattle portrait, 1864. *Seattle Public Library.*

Local Native American agents, including Doc Maynard, removed over four hundred Native Americans from Seattle before the war started. The U.S. military positioned itself on a sloop of war called the *Decatur*. After a patient wait, the battle began with the *Decatur*'s guns. The gunfire kept the natives at a distance, but they returned fire. When the natives broke for lunch, the white settlers took advantage of this time to evacuate women and children and place them onboard the *Decatur*. However, when the settlers tried to retrieve their weapons from their abandoned homes, the firing resumed. This went on until around 10:00 p.m., and then all firing stopped.

The following morning, the settlers awoke to find their attackers gone, along with their food and other stock. The number of natives killed varies from source to source. No native bodies were found in Seattle. With lumber from Yesler's mill, settlers constructed two five-foot-high fences, eighteen inches apart. The area between the fences was filled with dirt. It took only three weeks to complete the protective layer around Seattle. The residents shook with fear over the recent events, but they vowed to protect their new city.

OFFICER DOWN

Dying for Seattle

L aw and order is a good way to cut back on the crime rate, but there are no guarantees in the world of police and criminals. The history of the Seattle Police Department goes back to 1869, when the city charter provided for a marshal as the city's peace officer. The marshal was elected by the voters for a one-year term. The first elected was Marshal John Jordan in 1869. By trade, he was a stonemason and worked on building foundations, brickwork and plastering for many of the buildings standing in Seattle today.

Jordan served as the town marshal in 1869. He was elected to the common council (predecessor of the city council) during Seattle's first municipal election, in 1870. Under the city charter at that time, elections were held by the common council.

Seattle's population nearly doubled in size between 1890 and 1900 and then skyrocketed by 1910. The municipal building was built during this extraordinary population surge. At 400 Yesler Way, the city constructed a municipal building in 1909, which provided space for the city offices, a jail, an emergency hospital, a police department and a health and sanitation department. The city purchased the property on Yesler Way in the 1880s. When originally proposed in 1904, officials hoped to create two buildings. One would comprise a jail, an emergency hospital and a courtroom. During the next two years, the city council added the police department and the health and sanitation department to the mix, and in 1906, all city offices were included. In 1916, the city offices relocated to the new County-City Building, which is now the King County Courthouse. This left the building

on Yesler Way to be used for its intended purpose, as a public-safety building, and it remained so until 1951.

Irving Ward was chief of police when the new building was opened. With a one- to two-year turnover, there were twenty-three police chiefs between 1909 and 1951. Each had the task of managing vices that were either regulated or not tolerated at all. The prohibition of alcohol between 1916 and 1933 contributed drastically to the burden placed on the Seattle police.

Jim Woolery served as marshal from 1882 to 1883. In 1883, an amendment to the city charter abolished the position of marshal and created a new position: chief of police. The standard term would remain one year. As the first elected police chief, Woolery would serve his term and then be reelected by the mayor to serve a second term, retaining the position until 1886.

Unfortunately, the pressures of a burgeoning population meant that in a few short years, complaints began to be made again about the condition of the jail, as it became overcrowded. Designed to house a maximum of 80 prisoners, by the time it moved to the new public-safety building in 1951, the jail held 552. In 1909, the city population was 219,263; by 1950, it grew to 462,981.

With the working conditions and overpopulation, the police force struggled to keep law and order. It didn't seem to matter that rules and laws were set. There is, and was, always someone out there in the public realm who would break them. Regretfully, it didn't take long for corruption and mayhem to find their way into the Seattle Police Department.

On October 12, 1881, Officer David Sires was sitting in James Smith's saloon on Washington Street when he heard shots fired outside. When he went out to investigate the noise, concerned citizens witnessing the mayhem pointed the finger to a man by the name of Ben Payne running away from the WA Chong Company. Sires took chase. The suspect stopped in front of Madam Malla's brothel and turned to Sires. Sires was not in his uniform, and the suspect turned to warn him to back off. Sires did not heed the warning. He was trained to stop criminals and intended to capture Payne and place him under arrest. Payne then shot Sires in the throat before fleeing on foot. While the shooting was not witnessed, spectators identified Payne as the man firing shots and fleeing the scene. Madam Malla heard the shot and went outside to find Sires on the ground. She blew her police whistle to attract attention.

Officer Jim Woolery tracked Payne to a room at the Aldus Restaurant and made his arrest. The murder weapon was never found, and Payne would claim the shooting was an accident. He would be held for trial in the city jail.

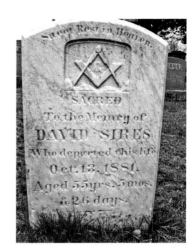

Right: Grave site of officer David Sires. *Karen Sipe*.

Below: Public hanging of James Sullivan and William Howard. *Seattle Public Library*.

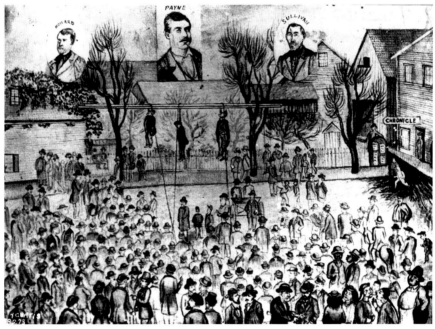

In the meantime, Sires would hold onto life for a few days before succumbing, thus becoming the very first Seattle police officer killed in the line of duty. Nine more officers would be killed in the line of duty within the next twenty years. The citizens of Seattle would prove they wouldn't sit around and allow criminals to get away with murder. The citizens wouldn't even wait for a trial. Instead, they would take matters into their own hands. That's exactly what they did to get justice for Sires.

On January 18, 1882, a mob seized two other men accused of murder and dragged them outside the courtroom, where they were lynched. A member of the angry mob shouted to go after Payne, and the crowd followed. Other prisoners were eager to direct the mob toward Payne. They dragged Payne to the area where the other two men were hanged and made him their next victim. Although Payne protested his innocence, his name would become infamous for killing the first Seattle police officer.

Officer Enoch Breece was one of the six police officers shot and killed by an escaped convict, Harry Tracey, who had been associated with Butch Cassidy's gang. After the escape, the convict murdered three correctional officers and three civilians. Then, on July 3, 1902, as an inmate of the Oregon State Penitentiary, Tracey killed three more men during an escape.

He fled the scene and invaded a home, where he took the family hostage and casually ate dinner. He engaged in a shootout as he left the house. At this point, he killed Officer Breece and another officer. He was taken into custody and committed suicide on August 6, 1902, by forcing a posse to fatally wound him in a shootout.

From 1906 until 1907 and 1910 until 1911, the twice-elected chief of Seattle police was Charles Wappenstein. Wappenstein was a colorful character and came to be known as Wappy to both friends and foe. Historian Murray Morgan describes Wappy as soft-spoken, with considerable warmth. His five-foot frame, girth and full mustache added to his personality.

Wappy's first order of operation upon his second election as chief of police was to call a meeting with the city's most popular gambling establishments and brothel operators. However, he wasn't closing them down. He had a deal to offer these top business professionals in the vice areas of town. For a certain price, they could continue running without any harassment from the police. In fact, depending on the price, he

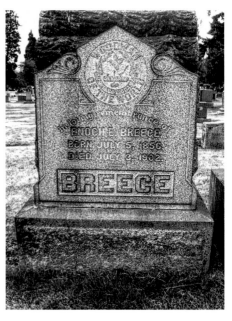

Grave site of officer Enoch Breece. *Author's collection.*

would offer police protection to the establishments in need. He was a tough police officer and chief. He was also corrupt.

Gambling establishments were popping up all over, and Wappy encouraged, rather than discouraged, their operations. He ruled the roost by having the mayor, Hiram Gill, in his corner, and the two got along like old schoolmates. Gill remains one of Seattle's most questionable characters. His policies confirmed his beliefs on sin: it should and could be confined to certain areas of town. As long as it stayed where it belonged, there was no concern for the laws previously set.

The district of choice was known as Skid Row or Skid Road. Originating around 1850, it encompassed Pioneer Square, which was beginning to expand from the core. Skid Road was built on a slice of land from the top of First Hill and down into the logging mill. The term "skid row" started in Seattle. As timber was sent down the hill to Henry Yesler's mill, it left skid marks on the road. When a logger was fired, he was said to be sent down Skid Road. The area became synonymous with gambling, alcohol and prostitution, all of which were overlooked by the law as long as they remained in this one district.

Wappy would work with the mayor to oversee the construction of a five-hundred-room brothel, said to be the largest in the world at the time. He planned another meeting with the most notable gambling establishment and brothel owners. They agreed to pay a price, as it was either that or shut down their businesses. Wappy would then send his minions out to collect money from each business. Each brothel was required to pay ten dollars per month for each working girl. Part of this new taxing of businesses was to divide the seedy establishments from the family friendly. They had expected the wealthier establishments to make their way into skid row, but they were wrong. Entrepreneurs continued to operate high-class gambling clubs, brothels and saloons.

In 1911, Gill was up for reelection and lost to George Dillings. Surprisingly, most of the Gill votes came from women, who had just earned their right to vote. Dillings's first order of business as new mayor was to fire Wappy. Dillings found the tolerance policy under Gill and Wappy's reign started to fade. Brothels were shut down. And as suspected, a grand jury would eventually indict Wappy, and he found himself spending time at Walla Walla State Penitentiary. Just before Christmas 1913, the governor granted a conditional pardon to Wappy. He would die in Seattle on July 27, 1931.

Prostitution has been around Seattle since at least 1853, when Mary Conklin added a brothel to the upstairs of Seattle's first inn. A few years later,

John Pinnell would bring girls from San Francisco to work in his brothel. They did as they pleased within the city.

The police department wasn't always running on a straight and narrow path. Early corruption would repeat itself in an on-again and off-again manner, like a broken record. Seattle politics under the tolerance policy adopted by the city council and Seattle Police Department in the late 1940s up through the late 1960s made the general public wonder who was the criminal and who was the law. Under this new policy, Seattle police enforced gambling laws and shut down places involved in booking, or gambling, with large payouts. They would not enforce the war against places involving lower-stakes gambling. To avoid prosecution, those places would just need to apply for the appropriate license and follow the advice given to them by the police. Those who defended the tolerance policy argued that it protected Seattle from criminal enterprise and groups trying to establish operations in the city, putting a damper on organized gangs and crimes. Those opposed felt the police benefited from the payoff from the business owners with gambling licenses. They would pay officers off to avoid visits to their establishments and evade police attention. Breaking the law would be tolerated for the right price. Other vices monitored under the tolerance policy included prostitution and the consumption of alcohol. These, too, could be overlooked for the right price, a return to business under the supervision of Chief Wappenstein.

Corruption, scandals and police payoffs are known to occur in many large cities. One unique aspect of Seattle's tolerance policy is that citizens were not abiding by the state laws, either. Fortunately, this policy began to fade in the 1970s, and law and order reemerged.

4

THERE SHALL BE RIOTS

Death and Discrimination

Visitors to Seattle know when they have stepped into the International District. The street signs are no longer in English, sweet scents of Asian food fill the air and a foreign flair is felt by all who visit. Visitors are welcomed and encouraged to stop by to taste the cuisine and learn about the ancestry and culture of those who dominate the area. Today, Asian immigrants are welcomed in Seattle, but this hasn't always been the case.

The mix of emotions in 1860, when Chin Chun Hook arrived in Seattle to work for the WA Chong Company in Pioneer Square, was palpable. At the time, Seattle was little more than a one-street town with fewer than three thousand citizens. This section of town was shady at best, and therefore, immigrants were welcome to live there and start businesses. It was a rough area filled with gunslingers and gamblers; houses of ill repute were common.

While pioneers like Denny, Mercer and Yesler were well known and still common names in the Seattle area, Chin Gee Hee is not. However, this immigrant came to Seattle from China with hopes and ambition. He came to make a fortune and then planned to return to China. He was a successful businessman and the first to construct a brick building after the Great Seattle Fire in 1889. By the time he returned to China, he had made millions and contributed greatly to the construction of the railroads in Washington State. But Chin Gee Hee was not spared the trials and tribulations of life during this time. Those who arrived from foreign lands were wanted as workers and laborers. Some settlers thought of them as lower-class citizens and reacted to them as such.

The 1880s were not easy on Chinese settlers. It didn't take long for the locals to become restless in the areas around Seattle. In 1882, Congress passed an exclusion act meant to help the rising unemployment rate. The Chinese were blamed, and this legislation prevented Chinese from seeking employment and maintaining their current employment status. In some areas, Native Americans joined white settlers in forcing Chinese immigrants from their homes. Even the chief of police would stand by while Chinese were forcefully pulled from their homes and placed on ships until the ship captains refused to take any additional passengers. Those who wouldn't fit on the ship were returned to police headquarters. As they made their way, a struggle followed. Within two short months, there would only be around a dozen Chinese left in Seattle. Chin Gee Hee was one of the remaining twelve.

The Chinese were not the only ones being evicted from the city. Japanese immigrants were also placing stress on the economy by allegedly stealing jobs from the white settlers in the area. These immigrants, who came to Seattle to help build a railroad and a city, had positions until the railroad was completed.

The Great Seattle Fire would play an active role in the return of the Chinese to Seattle. The city needed major rebuilding, and the WA Chong Company was hired to help with the reconstruction. This meant the Chinese would be needed and, therefore, invited back to Seattle. Chin Gee Hee would play a role in both the rebuilding of Seattle and the rebirth of the International District. The Burke Building came to life in 1898 and was named for Thomas Burke, a lawyer, judge and railroad builder.

The location of the International District would eventually move from the Washington Street area to King Street, where investors purchased large areas with hope of putting down a permanent existence. By the late 1940s, the population was growing, but men still outnumbered women by 75 percent. The exclusion act was preventing immigration, and there were laws preventing Chinese from marrying non-Chinese.

Before the anti-Chinese riots, there was an influx of immigration from Japan. The number of Japanese quickly superseded the number of Chinese. The Japanese immigrants filled the positions previously emptied by the Chinese. During this time, Japan was not competing with the United States, and therefore, they were not included under the exclusion act. Furthermore, unlike the Chinese, the Japanese men could import wives and continue to build their population. To choose a bride, a Japanese man would send word back to Japan and ask his family to find one. A man would send a photo to be given to his prospective bride along with a ticket to come to the United States.

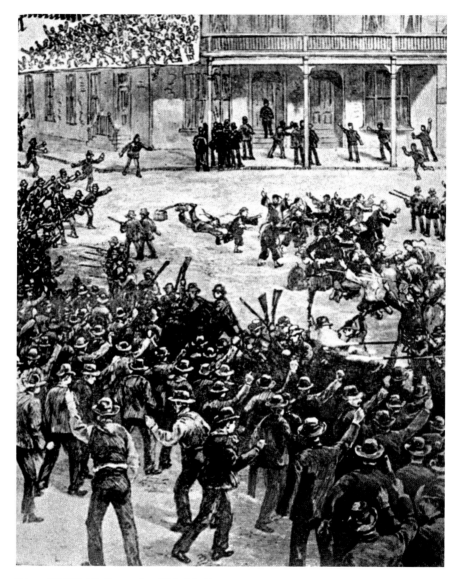

Riots of 1886. *Washington State Digital Archives.*

As time passed, the Chinese became more welcome in the city. A section of town that combined three smaller districts—Chinatown, Japantown and Little Saigon—became known as the International District. The population of this area is and was mostly Asian and can be divided by percentages. The Chinese hold 12 percent of the population, while the remaining population is a fairly equal mix of Vietnamese, Filipino, Japanese, Korean, East Indian,

The Burke Building, at the corner of Second Avenue and Marion Street. *Washington State Digital Archives.*

Indonesian, Laotian, Cambodian and Hmong. It's not surprising that the first in the area still hold the largest population.

The first Chinese housing was near Yesler's Mill and the Skid Road area. When the majority of the Chinese were driven out in 1886, some hid on the

Native American reservations, and others were concealed and protected by their Caucasian employers. They finally settled slightly farther inland. As land values rose, the Chinese were pushed to another area. The Japanese started to arrive and settle in the area as well.

The International District would be left alone for many years. In 1942, the relations between the United States and Japan were bad enough to be at war. In the wake of the attack on Pearl Harbor, the federal government began forcing Japanese out of Seattle once again. They were taken to camps and lived there from 1942 to 1946. When they returned after the war, most of the Japanese relocated in other areas within the city.

The Asian immigrants aren't the only people at the center of riots in Seattle. Mardi Gras, or Fat Tuesday, is a time of celebration that begins on or after the Christian feasts of the Epiphany and ends the day before Ash Wednesday. The French name, "Mardi Gras," reflects the practice of the last night of eating richer, fattier foods before the ritual fasting of Lent. This holiday is not traditionally celebrated in the United States, except for the South, where it remains a vital day of celebration.

Seattle's Pioneer District is in the center of the action and also the center of Seattle nightlife, with numerous bars and clubs. This area of Seattle celebrates Mardi Gras and has since 1977. During the celebration in 1979, more than ninety civilians and thirty police officers were injured.

The 2001 celebration would put an end to the yearly celebration, due to the events over the weekend prior to Fat Tuesday. Police estimated between four and six thousand people gathered in Pioneer Square after midnight on the Saturday before Mardi Gras. The crowd turned violent by throwing rocks and bottles at police officers after they made an arrest of a suspect with a handgun. Revelers smashed windows before they were dispersed by the police with an attack of rubber bullets, concussion grenades and pepper spray.

At the start of the festivities on Fat Tuesday, there were around four thousand partygoers flooding the neighborhood of Pioneer Square and the surrounding bars. An even larger crowd formed as nightfall cast a dark shadow over the streets. The final estimate was almost seven thousand people gathering in this one location. Standard Mardi Gras elements—alcohol, dancing and women baring their breasts to obtain beaded necklaces—all played a part in the celebration. Men from the crowd weren't complaining about the nudity but rather began groping any and every breast within an arm's reach.

Before midnight, as the alcohol, and quite possibly drugs, began to take effect, the brawling and fistfighting began. Police donned their riot gear and prepared themselves. The police force was originally ordered to form

a perimeter around the crowd and keep them contained to one area. They were not instructed to break up fights or enter the crowd.

The crowd started vandalizing cars and overturning a few. Small fires started, and the revelers broke the windows of nearby businesses. By midnight, there were reports of weapons being flashed and random attacks taking place. The Seattle Police Department was limited in manpower and had little to no control over the large mob of people. Paramedics were unable to reach those in need because the crowd was too thick and unwilling to let them enter.

At least one death occurred when a twenty-year-old from Auburn, Washington, Kristopher Kime, attempted to help a young woman in the crowd. While the police struggled to get the crowd under control, they missed rescuing a girl from being assaulted right under their noses. Kris stepped in, but as he bent over to grab the girl, he was struck on the back of his head with a skateboard by Jerell Thomas. In fact, video evidence would show Thomas striking Kime at least three times in the head with his skateboard. He was also convicted of striking two other men. Kris fell to the ground himself and struck his head another time. While he was lying helpless on the ground, other rioters began kicking his lifeless body. Kris's friends surrounded his body while someone went to alert the police, but because law enforcement had been instructed not to enter the crowd for any reason, they did not intervene. It was off-duty fire department workers who assisted Kris's friends, lifting him from the crowd and pulling him to safety. He was taken to a nearby street and placed in a police vehicle, which took him to Harborview Medical Center. Kris was placed on life support but only able to fight for his life for one final night before succumbing to death due to a skull fracture and subdural hematoma.

His attacker, Jerell Thomas, was only seventeen at the time of the incident. Thomas was convicted of second-degree murder in 2001. This conviction was later overturned by the appeals courts based on a prior ruling that an assault leading to death cannot be charged as murder. He was instead charged with the lesser charge of second-degree manslaughter and received a ten-year sentence. Thomas was released from jail in 2010.

The 2001 Mardi Gras riots in Seattle left a lingering effect in the city. The newspapers ran photos and articles in the following days. A photo of an African American man wielding brass knuckles became a symbol of the riot. The *Stranger* newspaper suggested the riot was racially motivated, reporting most of the violence was against white citizens. Witnesses agreed there were many racial slurs being tossed during the riot. They also suggested several of these threats came from local gangs primarily composed of African

American youths. The focus on the racial issues overshadowed the other crimes taking place in the city. There were many cases of inappropriate fondling of women and even sexual assaults.

In the days following the riots, a moratorium on Mardi Gras celebrations was set by Seattle's mayor. It was an election year, but for many voters, the support from the mayor came too late. Greg Nickels made a campaign promise to frame Kime's death certificate and hang it in his office if elected. He stated this was a reminder of the importance he placed on the office and how he would devote his time to making Seattle a better and safer place to live.

One day after the riot, Seattle experienced a 6.8-magnitude earthquake. This was the worst earthquake to hit Seattle in over thirty-seven years. The residents of Seattle turned their focus to the earthquake and the cleanup and away from the riot and the violence that had just taken place.

Mayor Paul Schell slept at home during the riots, but he did initiate a task force to uncover the events of the night. The task force was instructed to keep quiet about the lack of police support during the riots. A goal toward prevention of a repeat incident was not a consideration. The police department had not forgotten the riot, and an investigation and legal proceedings followed. The police chief admitted to ordering officers to form a perimeter but not enter the crowd. The City of Seattle would pay Kime's family a $2 million settlement. The first few meetings were closed to the public, but public outcry forced them to hold open meetings. All involved indicated citizens' lack of confidence in the current police chief and the choices he made that night.

Twenty-one people were arrested, and dozens of assaults were later discovered via the photographs, videotapes and eyewitness reports coming in from the public. One man photographed, Aaron Slaughter, was arrested on charges of assault on a woman and two men, as he was seen beating them with brass knuckles. The task force found roughly 75 percent of the assailants were African American. Of those, several were gang members and already wanted for other crimes.

Mardi Gras is still banned within Seattle city limits.

The World Trade Organization, or WTO, spread through various countries. The Ministerial Conference meets every two years and brings together all members of the WTO. Organizations such as the WTO don't please everyone. Some events from a riot during one of its conferences are often referred to as the Battle of Seattle. However, it was fought for much different reasons then the original Battle of Seattle.

On November 30, 1999, the WTO Ministerial Conference took place at the Washington State Convention and Trade Center in Seattle, Washington. This conference was to be the launch of a new round of trade negotiations. As the meeting began, it was quickly overshadowed by the forty thousand–plus protestors rallying outside the convention center.

The planning of this demonstration took months and included local, national and international organizations. Several groups banded together to protest against the WTO. The first group contained union workers who were concerned about the competition from foreign workers who would work cheaper and take their jobs. Asian imports do have lower prices. The environmentalists worried about the outsourcing of polluting activities. Consumer protection groups worried about the unsafe imports. The labor-rights groups worried about the poor working conditions in foreign countries. The left wingers simply wanted to vent about capitalism. Student groups, religious groups and even anarchists joined in the protest. These groups joined together to form an alliance.

The protestors started with a march from Seattle Center to the downtown district. Not all protestors were at peace. Some took a more direct approach and went straight to violence, destruction of property and civil disobedience. These loud and destructive methods were a tactic to disrupt the meeting of the WTO. Streets and intersections were blocked, making it nearly impossible for those who were simply trying to get on with their regular day at work or home. Some groups found specific corporations to target based on which ones were directly involved in their personal positions.

In the months leading up to the attacks, various newspapers ran articles on the WTO and, more specifically, the conference that would soon be taking place. Activists even managed to stage a spoof article in the Seattle-based *Post Intelligencer*. Several hoax editions of the paper were wrapped around the front few pages. The front-page story frightened a few hardworking citizens of the area. It stated the Boeing airplane plants were to move out of Seattle and continue their business overseas. The story's byline credited Joe Hill, a union organizer who had been executed by firing squad in 1915. Another article stated President Clinton was pledging help from the poorest nations.

On the morning of the conference, the full plan went directly into effect. The once-deserted streets by the convention center filled with activists, who went to work taking control of the main intersections of the road. In lockdown formation, they would quickly take control. The sheer number

of protestors in the streets blocked the WTO delegates from accessing the convention center from their hotel rooms.

Marchers split up and made their way to different areas of the city. The anarchist group made its way from Pike Street to Sixth Avenue, smashing newspaper boxes and windows of merchants along the way. Police formed a line, attempting to block the convention center and keep as many protestors in that one location as possible.

The King County Sheriff's Office and the Seattle Police Department banded together as a team, firing pepper spray, tear-gas canisters and stun grenades. The police were overwhelmed by the number of protestors and lacked the manpower to properly take control of the city. By late morning, the anarchist group had grown to well over two hundred people. They smashed windows and destroyed shops. They also destroyed and smashed every police car in sight. Some of the other protestors attempted to help stop the anarchists from attacking police, but they, too, were outnumbered by this point in the battle. The previously nonviolent protest progressed to a violent attack on the city and the people.

Before noon, the WTO declared the meeting canceled. This cleared the way for police to begin the task of clearing the streets and taking back control from the protestors. Governor Locke called for two battalions of National Guardsmen and support from surrounding law enforcement teams to assist the local police. Police and troops formed a barricade around the no-protest zone at the convention center. This angered some protestors. Rocks, bottles and police concussion grenades started to fly in the streets. This time, it didn't involve the anarchists. It was local residents. More than five hundred people were jailed on December 1, 1999.

The media took its own spin on the events. The *New York Times* told of protestors throwing Molotov cocktails at the police, even though this was not true. The paper did retract its statement two days later. This spurred a discussion on the availability and use of this improvised weapon.

The media condemned the violence of many protestors but stated people felt this fight was well justified and needed. In the end, the protestors viewed this riot as a success. The mayor's office didn't feel the same. Police chief Norm Stamper tendered his resignation. The size of the protest cost the city an estimated $3 to $6 million. This was partly due to police overtime and the cleanup expenses. In addition to the vandalism and property damage, these expenses would total over $20 million.

The City of Seattle settled with 157 individuals arrested, who agreed to pay a total of $250,000. And while the city fought to press charges against the

protestors, lawyers claimed individuals outside of the no-protest zone could not be charged, as the arrests violated the protestors' Fourth Amendment constitutional rights, without probable cause or evidence.

A yearly event that often turns into a riot occurs on May 1, or May Day. Each year, police prepare for a battle to take place. The first day of May has served as a date to demonstrate and support labor rights. For the most part, the protests are peaceful in nature.

Seattle has seen protests for the past four years. In 2012, the Occupy movement was taking place at the same time and held a rally downtown. Those plans were destroyed when over seventy-five anarchists took to the streets wearing black and smashing everything in sight. A handful of people were arrested as police subdued the crowd with pepper spray and blast balls.

The 2013 riot included daytime marches, rallies and protests. By nightfall, the demonstrators were wearing black and becoming destructive. Seventeen people were arrested, and eight police officers were injured downtown. Police considered their night successful.

In 2014, there was a peaceful daytime march. Anyone who would follow marched through the town. The demonstrators walked around Capitol Hill for over five hours. Ten arrests were made.

In 2015, peaceful marches again filled the streets. Police were able to contain the crowds. The police captain tweeted, "This is no longer a protest," but the protestors led police on a five-mile chase of nothing. The police were reprimanded for letting the crowd get out of control. Sixteen people were arrested.

In 2016, the Seattle police were prepared for a riot. To make matters even worse, May 1 landed on a weekend, and the weather was due to be nice and the sky filled with sunshine. It would appear, however, that the protests grow increasingly more violent in nature each year. It always starts with a peaceful march, but somehow, as the day progresses, it takes a violent turn for the worst. This year, the protestors lit fireworks and threw rocks and Molotov cocktails at the police. At least nine people were arrested during the riots.

It's unfortunate that the City of Seattle goes to such extremes to respect First Amendment rights. Property destruction and injured police officers are the price for allowing these protests to continue. At least one officer sustained injuries and lacerations to his face in 2016. Another officer was bitten. Yet a third officer was injured when hit by Molotov cocktail, but thankfully he wasn't burned.

In ancient times, May Day was a pagan festival celebrating the start of spring. More recently, it was declared International Worker's Day. In the

United States, Labor Day is celebrated in September. There was a time when May Day rituals meant knocking on a neighbor's door and leaving a basket of flowers before sneaking out of sight. How did this childhood ritual spark into a violent day of protests?

THE GREAT SEATTLE FIRE

From the Ashes, a Phoenix Will Rise

Seattle is often compared to a phoenix. A dying city bursts into flames, and from the ashes a new and improved city emerges. Not only would Seattle rebuild, but residents also would build a better city then the previous. Wooden buildings, sidewalks and streets were featured in early Seattle's architecture. After the fire, these were all replaced with components that could withstand time and the elements far better than wood.

Rumors of the wet, rainy weather have followed Seattle for many years. However, people often neglect to mention the times in which the rains don't fall and the lands below wither and die, leaving way for harsh forest fires and destruction. The highly wooded areas in Washington have contributed to forest fires throughout the state. They happened hundreds of years ago and still continue to destroy homes, buildings and wooded areas.

The spring of 1889 brought drought to much of Washington, and Seattle was no exception. It was not safe, with the possible devastation of a powerful fire. This dry climate left much of Washington vulnerable. The aforementioned wooden city would be at risk. A fire department was needed to protect Seattle.

The fire department consisted of volunteer men trained to extinguish fires. The hoses required a horse-drawn cart and pumps that brought water from the Puget Sound, through the hose and to the flame. It is rumored that during the early days of the fire department, a ten-dollar reward would be given to the first crew to arrive at the scene after the fire. This led to mistakes, including the men arriving on the scene without their pump car or fire engine.

Second Avenue and James Street, 1889. *Seattle Public Library.*

Another obstacle was the infrastructure. Few buildings of this time were built of stone or brick. Most were built from lumber and stilted to protect them from the many floods that destroyed lower buildings. With just the right spark, the entire building would be gone, and that is exactly what happened on one warm day in June.

On June 6, 1889, at around 2:30 p.m., the building standing on the corner of Front and Madison caught fire. Swedish immigrant John Back was working in the basement of Victor Cairmont's woodworking shop. Back chopped hard glue into smaller pieces and placed them into a melting pot on the iron stove. After that, he went on about his way, with other tasks waiting for his attention. Within moments, the pot began to simmer and then strike a full boil. The hot glue began to sputter out of the pot and burst into flames. Back responded promptly by attempting to douse the flames with a bucket of water. This caused the glue to fly and land on the floor, which was covered in wood shavings. A few sparks promptly turned into a small inferno and quickly engulfed the dilapidated wooden building. The small bucket is still on display at the Museum of History and Industry in Seattle.

Engine Company No. One arrived at the scene first and went to work attacking the flames. With multiple hoses hooked to fire hydrants, the rush of water made a little impact on the intensity of the flames. Nearby store owners began to clear their merchandise, anticipating the spreading flames. Fire chief

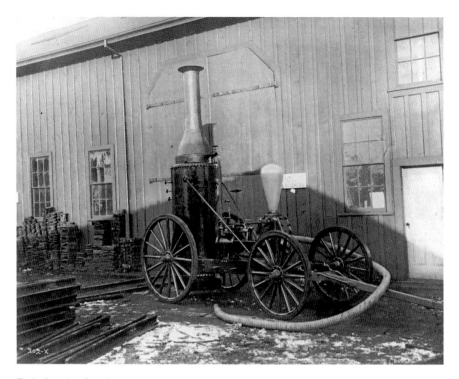

Early Seattle's first fire engine. *Seattle Public Library.*

Josiah Collins was in California at a meeting, and his assistant, James Murphy, was severely under-trained but took charge of the situation without hesitation. However, the small structure fire now covered city blocks, and Murphy was in over his head. He quickly began making poor choices. The fire moved from one block to the next. Smoke filled the streets for hours, and business owners did their best to evacuate their goods. However, there really wasn't an area to which to relocate the merchandise. Plus, many business owners were busy helping to extinguish the fire.

The summer of 1889 proved to be a time of physical and political changes in the city of Seattle. While no deaths occurred, mayhem filled the streets, and later news stories were not so accurate in the *Post Intelligencer.*

The original story tells of a fire starting in Jim McGough's paint shop located on the corner of Front and Madison Streets, which is now the Denny Block. For many years and through many published articles, McGough bore the blame for a fire that destroyed a major portion of downtown Seattle.

Early Seattle formed as one- to two-story wooden structures came to life. Streets and sidewalks were often made of wood. The city wasn't attractive. Everything was flammable, and fires quickly became a major issue in the city. Seattle's first hook and ladder company formed in July 1870. T.S. Russell served as fire chief. They had no vehicle and carried water in buckets to fires in the area. Without modern equipment, the task of fighting fires was daunting and not rewarding. The company disbanded soon after it formed.

The city council attempted to reduce fire risks by requiring all homeowners to keep a forty-gallon barrel of water. Those found without this barrel were charged a fine. However, this wasn't an effective method of fire prevention. Citizens did not comply, and laws were not enforced.

It wasn't until 1876, when a fire hit the commercial district, that Seattle decided to start the first permanent fire company. Seattle Engine Company No. One elected officers and adopted a constitution on July 6, 1876. They purchased a hand pumper trick from California and borrowed a hose cart from Port Gamble until they could afford to purchase one of their own. The progression from barrels of water to actual equipment would help develop the young fire company. The firefighters wouldn't obtain their first steam engine until February 1879. They proudly paraded their new engine through town to start a night of celebration marking the accomplishment and employed an engineer to maintain the engine in 1879 following a large

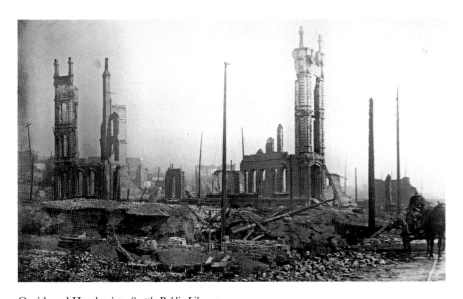

Occidental Hotel ruins. *Seattle Public Library.*

Fourth Avenue and Yesler Avenue ruins. *Seattle Public Library.*

Occidental Hotel ruins. *Seattle Public Library.*

fire that destroyed many businesses. They purchased a second engine in 1882. An authorized fire department would not come to life until April 11, 1884, when the City of Seattle made Gardner Kellogg the first official fire chief.

In the following years, the number of fire stations would increase, and slowly but surely they would add new and better equipment to their inventory. As the late 1880s approached, the enthusiasm for the fire department continued to decline. The only paid members on the team were the engineers and drivers. Approximately seven of the nearly four hundred people who formed the fire department received pay for their services.

While known for long days of rain, Seattle can also exhibit bouts of warm and dry weather. While not as great a fire as 1876, there was another fire that struck Seattle and left a mark. In March 1970, a fire consumed the Ozark Hotel. Residents ran screaming from their rooms as glass was breaking and flames filled the windows. One victim was killed when she dropped five stories to the sidewalk after slipping from the grip of the man holding her hand. While climbing onto the fire escape, he reached under her arm and gave it a tug, but she slipped and he was unable to save her from falling. She was only one of twenty who would lose their lives. This would make it one of the city's worst fire disasters.

It also set the precedent for laws and regulations that would stay with Seattle until the present day. The faulty alarm system and lack of sprinkler systems contributed to the large, engulfing fire. From the dates following the investigations, all buildings more than one story would be required to have a working fire alarm and sprinkler system. This has greatly contributed to the abandonment of the upper stories in many of the structures located in Pioneer Square. Funding has prevented the owners from upgrading and adding the required items. Without the upgrades, these buildings are not suitable for habitation.

STARVATION IN SEATTLE

Dr. Linda Hazzard

The small town of Olalla, Washington, is a short ferry ride from Seattle. For the most part, it is forgotten except for a few dilapidated buildings that mark the memory of long-gone farmers, loggers and fishermen who desperately tried to make a living in the area. There is, however, a haunting tale that begins in Olalla and will never be forgotten. It's best known now for the Polar Bear Plunge on New Year's Day, but it will always be known as the site of the infamous mass murders of innocent victims over a period of many years. And although the murderer was known, she would walk away with little to no repercussions for her crimes.

Born in Carver County, Minnesota, in 1867, Linda Burfield had a normal upbringing. She married for the first time at the tender age of eighteen and had two children. However, in 1898, she left her family to focus on her career as an osteopathic nurse. She would eventually call herself a doctor, even though she did not have training. Linda believed that every illness or ailment, no matter how large or small, could be cured with fasting. She believed all diseases were due to impure blood, requiring detoxing to clean the system and rid the body from disease. Fasting was the only way to allow the digestive system to rest and recover. This resting phase would give the body time to recuperate from any ailment. This practice was being used by other doctors, real doctors with medical degrees. And while there was valid information proving the efficacy of this method, Linda took things to an entirely different level.

Using her background in osteopathic nursing, she combined her fasting treatment with aggressive massage and daily enemas. The massage would go

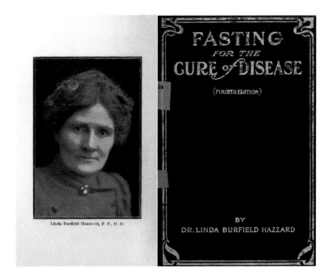

FASTING
FOR THE
CURE of DISEASE
(FOURTH EDITION)

Linda Burfield Hazzard, F. S., D. O.

BY
DR. LINDA BURFIELD HAZZARD

Left: Dr. Linda Hazzard. *Right*: Dr. Linda Hazzard's first published book, *Fasting for the Cure of Disease*. Seattle Public Library.

on for hours at a time and become quite violent in nature. Linda's massage involved pounding her fists on the patient's body in hope of forcing the toxins from the body.

By 1902, the first death occurred from the wild fasting treatment at Linda's hands. The coroner did attempt to press malpractice charges against Linda, but she promptly found a loophole. She wasn't a doctor and, therefore, couldn't be charged with malpractice. Charges were never pressed. Her patients solicited her assistance even after the deaths began to increase in number. When asked about the location of the money and jewelry for this patient or another, Linda just shrugged her shoulders. She never did divulge the location, but later her continuous thefts would come to light.

A few years later, as her divorce became final, Linda would marry another man. Sam Hazzard was already married, but it didn't stop him from marrying Linda as well. He would be charged with bigamy and face charges, as well as jail time, for this matter before devoting himself to Linda and her medical practice. He was known for his striking good looks and the distinct, constant aroma of alcohol that followed him around. Although he attended West Point, he was discharged from the military for misuse of army funds. With his career over, he could focus on helping his wife. Linda called herself Dr. Linda Hazzard, the name by which she is most famously known.

The couple moved from Minnesota to Olalla, just outside of Seattle, Washington, where they planned to build a magnificent sanitarium to hold the patients who came to Linda for treatment. While awaiting money for the construction of the sanitarium, Hazzard saw her patients in various hotels in

Seattle serving as makeshift hospital rooms. Their property would be known as Wilderness Heights, later called Starvation Heights.

Since they were new to Washington and their past was unknown, they were trusted and respected when they first arrived. The pretend doctor went to work straightaway seeing patients.

Most believed Hazzard was following in the footsteps of her mentor, and by 1908, she wrote her first book, *Fasting for the Cure of Disease*. Those seeking treatment felt Hazzard was a reliable source. She would eventually write ten additional books about her treatment and the benefits of fasting. All of these actions led her followers and the trusting citizens of Seattle to believe Dr. Hazzard was a breath of fresh air. Others saw her as a woman ahead of her time and someone who stood tall, as a woman working in a career traditionally dominated by men. What most didn't see is that she was a fiend. Her main goal was not to heal patients but to swindle the wealthy from their remaining funds and then starve them to death so she could inherit everything. She would accept wealthy clients and then talk them into transferring their properties and monies to her bank account. Her patients, for whatever reason, had faith in her and her treatment and didn't seem to notice the swindling taking place behind their backs. Perhaps they were too weak from the daily enemas, vicious massages (which would have been classified as beatings) or the depravation of something every human needs to live: food.

One of the Hazzards' first Washington victims was Daisy Haglund, a Norwegian immigrant whose parents once owned Alki Point. Soon after the release of Hazzard's new book, Daisy came for help and was placed on a fifty-day fast. She would die on her birthday without the promised cure of good health. Daisy left behind her husband and three-year-old son. Her husband did not blame Hazzard for his wife's death. In fact, for several weeks after her death, he continued to take his son to visit. He would remain faithful to Hazzard years later. Her son would later take his own place in Seattle fame, as Ivar Haglund opened a successful seafood business that still thrives in Seattle today. Many wonder if the fate of his mother had anything to do with his interest in food and making sure that no one ever starved again.

Excerpts from the diary of Earl Edward Erdman were uncovered and show the shocking details of a routine treatment from Hazzard. Erdman worked for the city of Seattle as a civil engineer and ended his experience with the starvation doctor when he passed away at Seattle General Hospital on March 28, 1910.

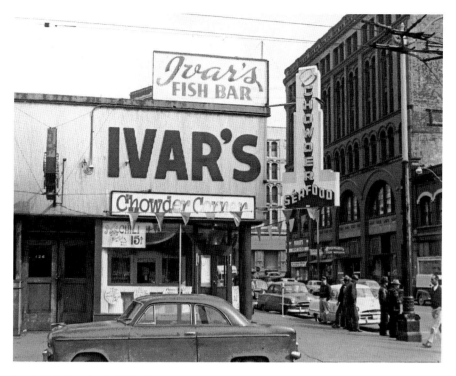

Ivar's Fish Bar. *Seattle Public Library.*

For many, this diary would be an eye-opener; people saw firsthand what the patients went through while under Hazzard's care at the sanitarium. Erdman began treatment on February 1, 1910, and he recorded that he ate two bowls of mashed soup: one for lunch and one for dinner. The next day, an orange was added for breakfast. By week two, he was decreased to one orange a day and eventually strained soup, which was a specialty of the doctor. She made her strained soups by cooking asparagus or tomatoes in a water broth. She would then drain all solid vegetables from the broth, and the patients received only the flavored water. By February 21, 1910, he was noting a backache, fatigue and dizziness. This erratic diet continued until he was hospitalized and died on March 28, 1910. When Hazzard performed autopsies, no one died from starvation, and in fact, she would say in her books that it was impossible to actually die from lack of food. However, Erdman died at a hospital, and the medical examiner performed an autopsy, concluding the cause of death was starvation. By the time of Erdman's death, there were already seven deaths directly caused by Hazzard's treatment.

One of those deaths was from a bullet to the head, but no one is certain if Hazzard fired the shot or if the man committed suicide.

In September 1911, two young and wealthy heiresses from Great Britain had just taken a trip to Canada and stumbled upon Linda Hazzard's book. Both women were relatively healthy, but they liked to travel and enjoyed trying new methods to become even healthier. They were also very curious about alternative medicine and reputed hypochondriacs. They started correspondence with Linda right away. The three continued to communicate for some time before agreeing to meet. Claire Williamson, the younger of the two sisters, had mild indigestion and thought the treatment just might cure her ailment. Dorothea, her older sister, went along to comfort her sister. They met with Linda Hazzard at her office in Seattle and expected to be turned down for treatment since they weren't all that sick to begin with. However, Hazzard eagerly accepted both sisters for treatment and wanted to start as soon as possible. She told the sisters that her sanitarium wasn't ready for patients but set them up with an acceptable hotel room in Seattle, which served a dual purpose of housing the sisters and a hospital or treatment area for Linda.

The sisters refrained from telling any family members of their treatment or where they were going because they feared they would be called hypochondriacs, or worse. They came from a straightforward family that might have frowned upon such a controversial treatment. This was a tragic mistake.

Even the sisters were in shock when Hazzard began her treatment of osteopathic massage just moments after meeting them. They started the daily enemas and massages. Neighbors nearby could hear at first the screams of pain from the intense massages and later the cries of pain from the starvation and tolls under which their bodies had been placed. A nurse hired by Hazzard went to visit the sisters often and feared they were close to death in no time at all. However, Hazzard was finding it difficult to obtain their money and power of attorney. She needed more time. The sisters' condition was bringing too much attention from the neighbors and now her own nurse. Hazzard needed to relocate them as soon as possible.

While Hazzard didn't have enough money to build the lavish sanitarium she desired, she could come up with enough money to build a few ramshackle cabins on her property in Olalla.

The Williamson sisters would be brought to the cabins in Olalla at the soonest possible time. They arrived via ambulance, weak and so malnourished that they were on the brink of death.

In a weakened state, Claire Williamson signed over her portion of her inheritance to Hazzard's practice. In the same breath, she held onto enough sanity to start fighting for her freedom from the curse they were both under. She tried to help her sister, but Hazzard wouldn't allow it. The sisters would be separated and brought into the main house. They were not allowed to visit with each other, and due to the state of their health, they could barely move for their treatments, which were still just as vigorous as the very first. At one point, Claire could reach Dora, but from then forward Hazzard attempted to put a wedge between the sisters by telling them each was too sick to see the other and that they just plainly did want to see each other.

Dora became upset and decided it was time to take action. She told Hazzard that she wanted to leave the sanitarium and would be taking her sister. This was not acceptable to Hazzard. Dora then sent a telegram to their family friend Margaret Conway that would save the life of at least one of the Williamson sisters.

Neighbors of the sanitarium knew about the treatments being held there and that the majority of the patients were skeleton-thin. The patients walked daily, as it was required in their treatment, and as they grew thinner and thinner, their walks became crawls. Neighbors watched this progression without knowledge of how to save the people, who didn't want to be saved. Even at the brink of death, Hazzard's patients felt they needed her to recover from their ailments and must follow Hazzard's instructions.

Conway met with Linda at her office in Seattle and was shocked to learn that Claire Williamson had passed away. Claire weighted a shocking fifty pounds at her time of death and died in an upstairs bedroom in Hazzard's home. She was too frail to fight. Her sister Dora weighed about the same and was barely hanging on to life. Conway demanded to take Dora home with her but was promptly informed that she was much too weak to travel and unbalanced mentally to make any such decisions. To ensure Dora couldn't and wouldn't leave the sanitarium, Linda told Dora that Claire's last dying wish was for Dora to remain there until she died. She also contacted the county officials to seek guardianship over Dora due to her mental instability. Once this was proven and guardianship granted, Linda would have full control over the Williamson sisters' estate.

Conway stayed in the tiny cabin with Dora for some time after her arrival. She wanted to leave and take Dora with her, but Hazzard prevented this from happening and at one point convinced Dora to stay.

Conway watched as Hazzard paraded around in the sisters' silk gowns and jewels. Conway sneaked a telegram to an uncle in Portland, who would come to Olalla and save the two women. When rescued, Dora weighed sixty pounds. As they left, Hazzard presented them with a bill for $2,000 and wouldn't allow her to leave without paying. The uncle negotiated a smaller amount and pulled them away to safety. Not many doctors will hold a patient against their will until their bill is paid in full. However, Hazzard wanted every dime possible, and Dora's family wanted her out of the crazy doctor's care.

British vice consul Lucian Agassiz was outraged and felt Hazzard had tricked and manipulated the Williamson sisters with her temptation of perfect health. His anger was enough to spark an investigation into the sanitarium and the treatment of the patients there. He gathered a list of patients who had been treated by the so-called doctor. Some survived and did claim to be cured by the treatment of starvation, osteopathic massage and enemas. Nevertheless, many others died of starvation. In fact, he proved death certificates signed by other officials marked the cause of death as starvation, while the ones signed by Hazzard marked the original illness as the cause of death. Wasn't her cure supposed to take care of the original ailment of her clients?

Finally, Hazzard went to court to present her case. A crowd of men and women gathered for the court hearings. The strong personality of Linda Hazzard drew out many women. She played to the crowd in an attempt to gain their acceptance. In the audience sat some of her former patients who had escaped near death and claimed to be cured. They were accompanied by a number of family members of former and present patients who all supported Hazzard and her unusual methods.

Hazzard was called a financial starvation specialist by the prosecuting attorney, who had ample ammunition against her. He would even go on to prove Linda was the one who signed Claire's will and the last entry in her diary. The judge denied access for former patients to speak on Linda's behalf. One Hazzard supporter who attended the hearings was Daisy Haglund's husband. Even after his wife had died under Hazzard's care many years earlier, he still believed in the starvation technique.

The trial lasted three short, but eventful, weeks. The judge made continuous comments on the training and coaching Hazzard received from her counsel. The vice consul's home had been broken into and a chest filled with Claire Williamson's belongings gone through. Police suspected a Hazzard supporter was to blame for the break-in.

In the end, Hazzard lost the trial. On February 4, 1912, she was charged with manslaughter and sentenced to two to twenty years at the state penitentiary in Walla Walla, Washington. Her medical license was revoked. She would only spend two years in prison until she received a pardon from the governor. The reasons behind her pardon were never revealed. Her medical license was not reinstated. She and her husband moved to New Zealand, and she continued to practice her starvation cure on unsuspecting victims.

Interestingly enough, when Hazzard fell ill, she attempted her own specialized treatment of starving the ailment from her body. After trying the treatment on herself, Hazzard died from starvation in 1938 at the age of seventy-one.

What happened to Claire Williamson's body after her death? Mysteries surround this matter, but one fact is known. Hazzard seemed to have a connection with a Seattle mortuary run by Edgar Ray Butterworth. Hazzard's attorney happened to be a close friend of Butterworth. Many felt this was not a coincidence. Some say Hazzard and Butterworth were great friends. Butterworth denied they were anything more than business associates who completed several transactions together. After all, a doctor starving her patients did need someone to help bury the bodies. Williamson's body was removed from Hazzard's property by E.R. Butterworth and Sons Mortuary with a license. O.C. Gove, a Butterworth employee, stood before the Kitsap County courtroom and pleaded guilty to this very task. This one fact would create a spark of conversations implementing Butterworth in running a dirty mortuary.

Could a man who started his business turn evil with greed when it came to making money? Butterworth's life with death and skeletal remains began in Kansas in the 1870s. He was an enterprising young man who made a living by gathering bison bones and selling them to manufacturers, who would grind them to dust for fertilizer. One day, while out collecting bones, he came across a man who had just lost his wife and child. The man was distraught and visibly shaken, as he had no means to bury his family. Butterworth looked to his wagon and back at the man. With very little concern for himself, he began to disassemble his wagon and build his first coffin.

Ten years later, he and his five sons traveled to Seattle, where he purchased Cross Undertakers and renamed it E.R. Butterworth and Sons. The undertaking proved to be lucrative, and before long he was able to purchase a nineteen-thousand-square-foot mansion in Queen Anne. The new funeral

parlor would be one of a kind and unlike any other seen in the United States. In fact, in 1903, the *Seattle Daily Times* reported Butterworth had the most complete establishment in the United States and was the first to use the words "mortuary" and "mortician" in connection with undertaking.

Butterworth's trouble began when people saw the bodies of their loved ones after death. His embalming preserved the dead to a point where they didn't look dead. This technique was used in Europe but new to the United States. As the developments of the Hazzard case opened up, the people of Seattle began to wonder if Butterworth was involved in the hiding of bodies or if he was running a legitimate business. These questions were never answered, and the mystery remains.

THE MAHONEY TRUNK MURDER

Married for Money

High-profile cases are repeatedly in the public's attention when it comes to marriage, divorce and domestic violence. Anna Nicole Smith, a young, beautiful woman, was twenty-six years old when she married an octogenarian billionaire by the name of J. Howard Marshall. He lavished her with expensive gifts during their two-year affair and reportedly asked her to marry him multiple times, but she declined. In 1994, she finally said yes. The news made the news, and gossip began. Why would someone young marry someone so many years her senior, unless she had ulterior motives? Reports told of a sexless marriage of a couple who didn't even live together. Anna voiced her love for her husband regardless of their age difference or what people were saying. Just a little over a year after their marriage, J. Howard Marshall passed away, thus creating a court scandal in which his son and family would fight Anna to protect their father's billion-dollar estate from falling into her hands. She wasn't in the will but claimed J. Howard had promised her half of his estate if she agreed to marry him. Anna would not see any of his money before her death in 2007.

There are many other cases of women who marry older men for their wealth in hopes of being financially supported. The elderly men lavish gifts on their young, beautiful wives expecting very little in return. As they age, they pass and often leave the luxurious estates to their wives. It's an easy way to go from poor to rich. Money breeds greed. Greed leads to mayhem and sometimes even murder. There are fewer cases of a young

man seeking to marry a wealthy older woman. However, Seattle has one such case that has left a mark on the history of the city.

James Mahoney faced conviction for drugging and robbing a Spokane man. For his crimes, he was sentenced to five to eight years in the Washington State Penitentiary in Walla Walla. His mother and sister would come to his rescue and orchestrate an early release with the governor, who was a former neighbor of the Mahoney family. James, or Jim, as he preferred to be called, was thirty-six when he moved to Seattle to live with his family in December 1920.

In 1920, Kate Mooers, age sixty-eight, owned a small hotel in Belltown called New Baker House, on First Avenue. She was also a part owner of the Sophia Apartment complex on Denny Way, where she lived. She became very affluent after she divorced her husband, Dr. Charles Mooers, who practiced as a physician and surgeon. Kate liked to show off her wealth by dressing in the finest clothing and adorning her body with the most expensive diamonds and jewels. She drove a fancy car and had an estimated fortune of over $200,000, which in 1920 made her a very rich woman. Kate was also known to be eccentric, short and balding. There would be no question as to what attracted Jim Mahoney to his future bride. He wanted what she had—money.

Jim Mahoney's mother, Nora, managed the New Baker House, and his sister, Dolores, maintained rooms and collected rents from residents. Mahoney was promptly introduced to Kate, and after a frighteningly short courtship, the two married in a civil ceremony on February 10, 1921. He then took up residence in Kate's apartment. A short courtship and casual wedding left the couple little time to celebrate their nuptials. In May, the couple began planning a honeymoon to Saint Paul, Minnesota, and arranged to be away for at least one month.

On April 15, 1921, Kate withdrew money from her safe-deposit box and purchased several hundred dollars in American Express traveler's checks. She let her neighbors know she and Mahoney would be traveling on their honeymoon and leaving late the next evening. As planned, the following day they left the apartment and made their way to the train station on King Street. Everything up until this point seemed normal and uneventful. Just eleven days later, on April 27, 1921, Jim returned home without his wife, Kate. Neighbors questioned her whereabouts, but this was easily dismissed by telling them he had decided to return home, while Kate chose to extend her travels a bit further. He told them Kate wanted to visit Havana, Cuba.

Being the kind and thoughtful husband, Mahoney returned home to take care of Kate's business interests in her absence, and they planned to meet up at a later date in New York City.

Mahoney punctually drew up papers with the county auditor's office and was granted access to his wife's property. Everyone believed he was keeping his promises to his wife and taking care of her business affairs. What the friends and neighbors didn't know is Mahoney had also cleaned out Kate's safe-deposit box, collected rents and attempted to convert all of her real estate properties into cash. The once common man began buying fine tailored suits and dressing in the high style to which Kate was accustomed. Again, this could be dismissed. A woman of Kate's stature would surely want her man to dress his part and look like a successful businessman. Dressing like Kate wasn't enough for Mahoney. He also began to wear items that belonged to Kate. In fact, he was seen at a nightclub wearing one of her diamond pins and driving her Westcott sedan.

The actions of Kate's new husband triggered concern from her friends and relatives. They couldn't understand why Jim was changing and why Kate had yet to return to Seattle to join her husband. Jim's excuses were wearing thin on the concerned bystanders. He did little to ease their trepidations, and at first he simply refused to respond or tell them where Kate was staying. Letters would arrive addressed from Kate, but friends and family agreed they were not in her handwriting. Suspicions were growing. When Jim did start to talk, his stories often changed. He would say he and Kate had a lover's quarrel and then she traveled to Cuba with friends. His stories weren't matching up and certainly were not satisfying the concerns of Kate's acquaintances.

In May 1921, Kate Stewart, one of Kate Mahoney's nieces, met with the Seattle police to voice her concerns. Police provided handwriting samples that indicated the letters did not actually come from Kate but were indeed forged. Stewart explained the odd behaviors Jim was exhibiting, such as spending large amounts, removing money from Kate's safe-deposit box and lack of concern that his wife wasn't returning to Seattle after such an extended vacation. With the evidence presented, police believed foul play could have occurred and were fascinated enough to start an investigation, which would start with questioning Jim Mahoney.

Seattle police detectives didn't take long to track down the trail of events that took place on the evening Kate was last seen. Mahoney telephoned a company to help transport a heavy steamer trunk. The hefty trunk was moved from the apartment to a car with the help of a man from the moving

company. Mahoney drove to a houseboat on Portage Bay, where the two men loaded the trunk onto a waiting skiff. Mahoney explained to the man that he was transporting the trunk to his houseboat. No further questions were asked, and Mahoney rowed away into the dark night.

Police spoke to a woman who told them Mahoney had inquired about renting a houseboat to do some fishing in the deepest parts of Lake Union. This was two days prior to Kate and Jim leaving on their trip. Police also tracked down the owner of the white skiff Mahoney rented to get to the houseboat. When Mahoney hadn't returned the skiff, the owner found it sunk in the shallow water by the houseboat.

The next clue for detectives was learning Mahoney had visited the offices of Emil Brandt, an attorney and notary. He was accompanied by a woman posing as his wife, not identified as Kate Mahoney. The unknown woman requested power of attorney, which would allow Jim Mahoney to access Kate's estate. Brandt knew Kate, and she was not the woman in his office. Mahoney would stop by to purchase the hemp rope used to move the trunk. He also forged some of the traveler's checks Kate had purchased. Kate was busy visiting friends and preparing for their vacation.

Police also discovered a hidden secret of Mahoney's past. He was already married to a woman named Irene and had never legally divorced her. Irene left Mahoney when she learned he was smuggling opium, and he tried to kill her. Now they had a motive—money and Mahoney's dark past—highlighting him as a murdering type.

The Seattle police were missing one key item: a body.

Inside the trunk was a body that had been severely decayed by quicklime. Items inside the trunk included women's clothing, personal items and, most damning, Kate Mahoney's false teeth and wedding ring. Autopsy results would reveal Kate died from poisoning by morphine and blunt-force trauma to the skull. Kate's demise would prove to be a sad one. Officials believe she was still alive when first placed inside the old steamer trunk.

Jim Mahoney would be charged with the first-degree murder of his wife and enter a plea of not guilty. Only twelve jurors would be selected for the September trial. Judge James Ronald didn't want a delay in searching for an alternate juror and ordered the trial to begin.

Opening arguments would present the information obtained by police with the help of Kate Stewart. However, Mahoney's attorney described an entirely different version of the events. In his version, he tried to prove the body in the trunk was not Kate Mahoney and that she was alive until at least

April 16, 1921, when Mahoney left her side, providing Mahoney with an alibi for the time of death. They called in twenty-seven witnesses who said they saw Kate Mahoney alive after April 16, 1921. Several even said they attended a party at the New Baker House hosted by the couple. Of course, two of the witnesses were Mahoney's mother and sister. They claimed Mahoney's trunk was full of illegal liquor and that anyone who testified as to the identity of the body was lying to the courts.

The jury convened to their quarters to discuss the verdict, and just five hours later, they returned with a verdict. Not only had they found Jim guilty of first-degree murder, they also voted to impose the death penalty.

The case didn't end there. Just four days later, police would arrest Dolores Johnson, Jim's sister, for forgery and larceny. Police believed she was the one who signed as Kate on the paperwork turning everything over to her brother.

Many requests were made to overturn the case against Jim, but they were denied. In late November, he would do the unthinkable and confess entirely to the murder of his dead wife. His intricate details of the murder matched those presented before the jury during the trial. Most believe he confessed to take the weight off of his mother and sister, but Jim told people the murder itself was all Kate's fault. While he expected her to share her wealth with him, she didn't trust him with money and nagged him too much.

Little did he know, his sister would confess to everything the following day. She claimed to have killed Kate after a heated debate and stated that her brother's only guilt was helping her hide the body. Her statement was full of errors and did not save her brother from his ultimate doom. Dolores would face trial and conviction of forgery and grand larceny. She would continue to fight her jail sentence of five to twenty years, stating she was innocent, but she was consistently denied release.

The gallows were erected on Thanksgiving Day, November 30, 1922. The hemp rope noose was tied. Mahoney's last meal would be a traditional Thanksgiving dinner. He spent the evening lying in his cot eating chocolates and reading the newspaper. He called in a priest around midnight and confessed his sins before his last rites were administered.

The execution was witnessed by prison officials on December 1, 1922. His body hung for a full twelve minutes before it was lowered and vital signs checked, proving James Mahoney was dead. Funeral services were held on December 11, 1922, and the body was laid to rest in an unmarked grave in Walla Walla.

With Mahoney dead and Dolores in jail, it would seem not one Mahoney benefited from the money stolen from Kate or her death.

Just thirty minutes east of downtown Seattle, another man became famous for killing his wives. Not one, but two women died at his hands.

Randy Roth moved to Washington in the late 1950s. Rumored to be a class bully in high school, Roth enjoyed playing cruel pranks on innocent bystanders. After graduation, he joined the marine corps but served as a file clerk rather than seeing any combat. In less than a year, he was discharged when his mother wrote a letter stating there was a hardship on the family with him being gone. Roth became engaged and married soon after returning home. His wife would give birth to his son shortly after his first stint in jail for robbery. Without warning or cause, Roth filed for divorce just after his son's birth.

Early in 1981, he met Janis Miranda. She was also a divorced single parent. They married a short time after meeting. Upon buying their first home, Randy insisted on purchasing ample life insurance for his wife. He told her it would provide security for him and the children if the worst should happen. Janis's friends noted a sudden change in her behavior.

On the day after Thanksgiving in 1981, Randy and Janis went for a hike at Beacon Rock just east of Vancouver, Washington. Only one of them would return home that night. Janis took an unfortunate plunge to her death. The only witness was her husband. When police were able to retrieve her body, they promptly noted foul play. Randy's story and the body's location didn't agree. It was suspected that Randy may have pushed her, but they didn't have enough evidence to make an arrest. The very same day, Janis's body was cremated, and Randy filed a claim for life insurance instead of notifying friends and family.

In 1985, Roth married Donna Clift, a twenty-one-year-old mother with a three-year-old daughter. Roth played mean jokes on Donna's daughter and quickly went about showing his true colors to Donna as well. During a dangerous family rafting trip, Roth attempted to steer their raft into sharp rocks. Donna began to fear for her life and filed for divorce.

Roth's next fiancée had recovered from cancer and therefore wasn't insurable. So he broke off the relationship. If he couldn't profit from the untimely death of a spouse, then there was no reason for him to marry.

He remained single until 1990, when he met Cynthia Baumgartner. She had two sons from her previous husband, and in August 1990, the couple ran off to Vegas and married. This surprised friends and family, as it wasn't in her nature. Before long, regret would fill Cynthia's heart when she watched Roth physically and mentally abuse both of her children. Friends who knew that Cynthia always looked her best began to question why she no longer seemed to care about her appearance.

On July 23, 1991, just a few weeks after their anniversary, the couple took a trip to Lake Sammamish. The boys stayed in the designated swimming area, enjoying the ninety-degree summer day in Seattle. Randy and Cynthia went ahead in their raft. When they returned to the boys, Cynthia was unresponsive. She was taken to the hospital, where she was pronounced dead. Again, Roth had no witnesses to Cynthia's death. He claimed the raft overturned in the wake of a passing speedboat, and Cynthia drowned.

With no solid evidence of a forced drowning, police didn't have much to go on other than Roth's lack of emotion while retelling the story and the contradictions of his account of the events.

Following the same path as he did when Janis died, he promptly filed a claim for the large life insurance policy he held on Cynthia and cremated the body before notifying anyone close to Cynthia. After three months had passed, he was certain he had gotten away with murder, again. However, this time police would arrive at his place of work with an arrest warrant and a search warrant for his home.

With no physical evidence of a forcible drowning or eyewitnesses, detectives had their work cut out for them if they were to bring any kind of a case against Roth. The motive started to become crystal clear when detectives uncovered the trail of life insurance policies, which were now making Roth a wealthy man. It seemed he was financially profiting from the deaths of his late wives. Roth had many lavish items in his home—items the average mechanic simply couldn't afford. In fact, his tax returns would show a mean, modest income of around $20,000 to $30,000. Even so, he owned multiple cars and other expensive items.

Cynthia's sons were interviewed. They told a tale of an abusive man who knowingly stole from his employer. They also said he showed little emotion over their mother's death and had started clearing the home of her belongings just days after her death.

Investigators reopened Janis's death records to find she had died under similar circumstances. They learned that in both cases, Roth lacked emotion over the passing of his wife, speedily cremated the body and collected a large insurance policy. Police now had a pattern and a motive, but would it be enough to convince a judge?

During the trial, Roth's defense team frantically attempted to have the entire case thrown out on lack of proof. They would fail.

A packed courtroom of family, friends and press gathered to listen to the details of the deaths of both Janis and Cynthia. Roth remained emotionless throughout. His lawyers told the jury about a man who had a stream of

bad luck and unfortunate events leading up to the death of not one, but two wives. The prosecution wove the story of a thief and murderer who didn't shed a single tear at the passing of either wife. In the end, Roth took the stand for over twenty hours, as both teams questioned him over and over about the events leading up to both deaths.

It only took the jury a little over eight hours to return with a verdict of guilty on one account of first-degree murder and two accounts of theft. Formal charges in Janis's death would not be pursued.

Sentenced to fifty years in prison at Stafford Creek Correction Center in Washington, Roth would keep only one supporter. His first wife, who still had no idea why Roth divorced her, remained his defender.

MURDER AT GREEN LAKE

Sylvia Gaines

Murder is a tricky business, which is why police have such a struggle when it comes to capturing their suspects. Today, scientists help with the forensic end of the investigation. In late 1971, anthropologist William Bass created a facility in Knoxville, Tennessee. This research facility housed at the University of Tennessee consists of over two acres of a wooded area surrounded by a razor-wire fence. Inside the fence lie over one hundred decomposing human bodies placed in a variety of situations. Known as the body farm, this facility is a classroom for forensic anthropologists to study death and human decomposition. The information collected is used to assist law enforcement in the difficult task of determining the cause and time of death. While these types of studies provide a mountain of knowledge, they don't always provide all the answers. Sometimes law enforcement is stumped, and on occasion a murder will remain unsolved and drop into a deep, dark location called the cold-case files.

One such case is the death of Seattle's Sylvia Gaines. Some will agree and others disagree that this case is the oldest unsolved murder in Washington State. Most will agree that it is one of the most interesting cases in Seattle's history. She was a beautiful, intelligent college graduate, and her uncle William Gaines was the chairman of the King County Board of Commissioners. The story would make front-page news, as Seattle was shocked and fascinated by the life and death of Sylvia Gaines. A man was sentenced, convicted and executed. Many believed the evidence ultimately concluded they had the right man. However, questions lingered, and public

doubt has left Seattle residents thinking twice as they walk along the shores of Green Lake. Did police catch the right man?

On the morning of June 16, 1926, two workmen by the names of J.L. Reynolds and O.B. Ripley were walking the north shore of Green Lake in Seattle when they discovered a pair of women's slippers. As they investigated further, they discovered a bloody trail and a young woman's body lying on the ground in tattered clothing. They also located a white felt hat near the water, which police felt proved a struggle in the lake. The coroner noted Sylvia died in the water, which supported the supposition she was choked on land before making an effort to escape by swimming in the cold waters of the lake. Dirt on the heel on her right shoe indicated the body was moved or dragged after death, and the state of her clothing pointed to sexual assault.

This wasn't the only murder in the area during that time, and reporters and police alike were eager to link Sylvia's murder with those of the assault on a girl in the University District and First Hill. Those suspected of the attacks were promptly brought in for questioning. Police questioned Sylvia's former boyfriend as well.

The investigations would come to a halt when a prime suspect stepped forward: Wallace Gaines. He was better known as Bob Gaines and Sylvia's biological father. Bob told police that he was outside watering his lawn when Sylvia left for a walk. It was not an unusual behavior for Sylvia to go on a nightly walk, sometimes even after dark. However, as the details of this young woman's life came to light, the public was shocked.

Sylvia Gaines was born in Natick, Massachusetts, in 1904, and lived in Lynnfield. She graduated from Peabody High School in 1921 and then attended Smith College in Northampton. Her parents separated when she was around five years old. Bob Gaines left Sylvia and her mother behind and moved to Washington State. Sylvia's parents divorced a short time later. Being so young, Sylvia would not have had the opportunity to get to know her father, and he didn't visit her in Massachusetts. Upon graduation from Smith College in 1925, Sylvia decided to venture west and met her father. She intended to stay for a short visit and then return home. However, she would never leave Washington State.

When Sylvia's body was first discovered, her father was not suspected. He reported his daughter missing on June 17, 1926. After the workmen found the body, Bob went to the morgue to identify her. Ewing Colvin, the King County prosecutor and friend to Bob's brother William, found it impossible for Bob to be a suspect. After all, what kind of father would be capable of killing his own daughter in cold blood? This was a common thought among

the police, the press and the general public. The assault and murder that resulted in Sylvia's death had to have been done by a madman or fiend.

When police questioned Bob on June 17, 1926, he was intoxicated and even hinted that he knew the identity of the murderer. Police questioned people in the Gaineses' neighborhood but only learned that he was drunk and distraught that his daughter was not at home.

During questioning, Bob was tearful and demanded a quick trial even before he had been charged in the crime. He was allowed to attend Sylvia's funeral and didn't shed one tear during the entire ceremony.

The murder trial began on August 2, 1926. The twelve jurors, including nine men and three women, were sequestered in a downtown hotel to avoid the media and public attention drawn to the case. Ewing Colvin, the prosecutor, would ask for the death penalty.

While once believing in Bob Gaines's innocence, Colvin had a change of heart and worked quickly to dissolve the theory of the murderer being a fiend or stranger to Sylvia. After all, no screams or struggles were heard the night of the murder, which seemed to indicate she knew her assailant and did not fear the person.

Reports from witnesses would point fingers at Bob for not only driving around Green Lake on the night in question but also standing on the spot where the body was located around the approximate time of the murder. Evidence brought forward from the crime scene and Sylvia herself proved she was strangled and then struck repeatedly in the head with a blunt instrument, which was believed to be the bloody rock located near her body.

Bob Gaines admitted to the jury and court that he had fought with Sylvia on the evening of her murder and stated that she left the house to walk off her anger. Bob left the home around thirty minutes later to look for Sylvia. When he couldn't find her, he said he proceeded to the home of Louis Stern, one of his drinking friends. However, Stern turned on his friend when pulled forward to testify. Stern stated Bob arrived at his home drunk and all but confessed to the murder of his daughter; she had been reprimanding Bob about his drinking problem.

As the trial progressed, the story of the Gaines family also proceeded to another level. Colvin could explain the where, when and how Sylvia was murdered but not why. He suggested that there were unnatural relations between Bob and Sylvia. When Sylvia arrived in Seattle in late 1925, she slept on the sofa of the small one-bedroom home Bob shared with his wife. For some reason, the three new housemates fought time and again and so badly that in November Bob's wife attempted suicide because Bob and Sylvia

talked about moving into an apartment. Witnesses would also state they believed Bob and Sylvia were sleeping together and had seen them acting romantic with each other, often in public places. The neighbors believed it was Mrs. Gaines who was sleeping on the sofa and Sylvia who accompanied Bob in the bedroom. Colvin would use all the new evidence to mount his case and prove a motive. Bob was upset that Sylvia was still setting up to leave Seattle, as it was her original plan, and she was finished with whatever Bob forced upon her daily.

A night clerk at the New Artic Hotel, now called the Artic Club, testified that Bob, Sylvia and his wife, Elizabeth, entered the hotel, but only Bob and Sylvia checked in for the night. Though they rented two rooms, a maid would testify to seeing the two together in one bed.

Colvin suggested that Sylvia left the house on the evening of her murder to get away from Bob, but Bob didn't let her go willingly. Instead, Bob followed her to the shores of Green Lake, and in a jealous, alcohol-induced rage, he killed her. The torn clothing was not from a sexual assault but rather to make it look like Sylvia was assaulted and take the heat off of her father. Some of the most damning evidence came from the forensic team verifying that there was human blood on Bob Gaines's clothing at the time of his arrest.

If there was any doubt in the mind of the twelve jurors, it wasn't evident. It took just over three hours for them to find Wallace Bob Gaines guilty of murder and sentence him to death. Bob sat icy calm as Elizabeth squeezed his hand. William Gaines crumpled onto the press table and sobbed. Through appeal attempts by both Bob and his brother William, the brothers would struggle to prevent an execution. Two years later, and the day before his execution, another prisoner at Walla Walla would attest that Bob had confessed to the murder.

Governor Roland Hartley refused all appeals and a petition to spare Bob Gaines's life. During a radio broadcast on the night before the execution, the governor made no mention of the Gaines murder case. When a reporter asked for a statement, the governor declined.

Grave site of Wallace Gaines. *Karen Sipe.*

On August 31, 1928, Wallace Bob Gaines was hanged at the gallows. He would become the twenty-fifth of seventy-eight people executed in Washington State. Long after the execution, his wife, Elizabeth, continued to profess his innocence, as did Bob in his last words written to his brother. He stated that he hated being hanged for a crime of which he had no knowledge and knew he was just a scapegoat for police to tag a suspect.

Ninety years later, Seattle locals are still talking about this fascinating case and debating the guilt or innocence of the man who was hanged for the murder of a beautiful young woman at Green Lake. The area where Sylvia spent her last moments on earth is still referred to as Gaines Point and visited by locals and visitors who enjoy the walking trail along the lake shore. Several trees were planted as a memorial to Sylvia, but time and weather began to take their toll, and the branches started falling on visitors. They were removed, and sadly, so was the memorial displayed for Sylvia.

On June 1, 1933, another body was located in a Seattle lake. Captain Jonah Miller had been stuffed into a weighted-down sea bag and tossed into Lake Union. He had been stabbed to death and then placed in the bag while he was still alive. He was robbed of his money, his knife, a watch and a ring.

The sailor had been reportedly missing for four months. He was discovered by four young people traveling via boat on the lake. Miller was known as a hardworking sailor, not someone who tended to find trouble or allow trouble to find him. Police had trouble investigating the crime, narrowed down to two theories: robbery or revenge. To date, the murder has gone unsolved.

THE GREAT SUICIDAL
DEPRESSION

The Great Depression originated in the United States around September 4, 1929, when the stock market crashed. It wouldn't become worldwide news until nearly two months later. The market crash of 2008 was only a 1 percent decline, compared to the 15 percent decline of 1929. This decline in stock value would affect both the wealthy and the less fortunate. It would last well into the mid-1930s and leave an unforgettable mark on the world and its people.

Seattle was not saved from the despair and hardship. Looking over the current real estate in Seattle, it's hard to believe that during the Great Depression acres and acres were covered by small tarpaper shanties, which provided shelter and living quarters but at a very degrading cost of living. Shack-filled towns and homeless encampments became known as Hoovervilles. The nickname was a deliberate poke at President Herbert Hoover and the Republican Party, which citizens held responsible for the economic crisis at hand.

The main Hooverville in Seattle was one of the largest, longest lasting and best documented in the world. It stood for over ten years, from 1931 to 1941. It covered over nine acres of land and had a population of well over one thousand people. This encampment elected an unofficial mayor of the area. While this may have seemed like a perfect solution and wonderful place to call home, the economy was in the dumps, and living in Hooverville was not pleasant. As more and more people lost their jobs, they also lost their homes and the ability to pay taxes. By

Above: Hooverville residents among the tall grass. *King County Archives*.

Below: Hooverville one-room shanties. *King County Archives*.

1932, millions of Americans were poor. Those who could moved in with relatives, but others squatted in vacant buildings, lived on the streets and found shelter wherever possible.

Those who moved into Hooverville found themselves in a one-room domicile scattered among a disarray of buildings. They also found themselves subject to rules and laws. Men of every color gathered in the community, but

Stumps around Hooverville. *King County Archives.*

women and children were not allowed. Sanitation rules were weak at best. Garbage lined the streets.

By the end of World War II, the Seattle Health Department had set forth a plan to clean up the cluster of homes and remove them. Residents were given a timeframe for eviction, and by May 1941, police offices doused the structures with kerosene, as spectators watched Hooverville disappear.

As one can well imagine, the depression of the economy did nothing for the emotional well-being of the people who were attempting to survive this hardship. The suicide rates skyrocketed. Suicide, generally a taboo subject, happens every day, whether we discuss it or not. People began to sink into despair and shame from their inability to obtain a job. The terms jobless and hopeless often accompany sadness and emotional depression. Suicide rates increased to the largest in history. Of every 100,000 people, 22 committed suicide during the Great Depression. In fact, in 1932, the main cause of death in King County was suicide. There were over 190 successful suicides and many more attempts.

In August 1930, two Seattle businessmen, Phillip Hidtch and Sydney McDonald, both committed suicide. They were just two of the many men and women who committed suicide between 1930 and 1933. Several of those committing suicide were at one time successful businessmen. During

this difficult financial time, people were feeling hopeless and depressed. There didn't seem to be a miraculous light at the end of the tunnel or an end to the money drought. Lack of sleep and food only added to the already strained bodies. Newspapers were filled with stories of death by suicide.

Also common during the Great Depression was grave robbing. People are often buried with their jewelry or expensive belongings. Grave diggers came into the cemetery at night and dug up the shallow graves. They would then strip the body bare of anything worth money. One episode tells of a young man who opened a coffin and found more than he bargained for: a live female.

The Aurora Bridge was erected in 1929 and opened to traffic in 1932, the final link in what was known as the Pacific Highway, or U.S. Route 99. Standing 167 feet above water and spanning 2,645 feet in length, the bridge was designed by the Seattle architectural firm of Jacobs and Ober. Ralph Ober would die of a brain hemorrhage before the completion of the construction in 1931. Opened to traffic on February 22, 1932, George

George Washington Memorial Bridge. *Seattle Public Library.*

Washington's 200th birthday, the bridge would be called the George Washington Memorial Bridge.

It wouldn't be discovered until later that the height of the bridge and pedestrian access would open the door to suicide jumpers, who found the bridge a perfect destination for their final resting place. Jumping from a tall bridge to the water or ground below can cause multiple organ damage, broken bones and death. Experts have tested the number-one suicide bridge, the Golden Gate in San Francisco, California. Jumpers travel at an estimated eighty miles per hour before suffering a gruesome death. Sadly, the second-most popular suicide bridge in the United States is the Aurora Bridge in Seattle. Recent statistics show that 230 people have died by jumping off this bridge. While this number may seem small in comparison to the Golden Gate's 1,600 deaths, it is high compared to the third and fourth bridges on the list. In 2011, a suicide barrier was built to reduce the death rates.

Nearly sixty years after the Depression, another suicide would bring Seattle into the national spotlight. This controversial death was that of a local rock star who played a vital role in the grunge scene and Seattle's music history.

In the mid-1980s, a subgenre of alternative rock came to life in Seattle. This new musical style, referred to as grunge, or sometimes Seattle sound, brought attention to Washington State and some of the artists who were responsible for the birth and creation of this new sound. However, the fad didn't fade in the early 1990s when the Seattle-based grunge band Nirvana, one of the founders of the genre, would lose their lead singer, Kurt Cobain.

Born in Aberdeen, Washington, on February 20, 1967, to a waitress and an automotive mechanic, Cobain was an average child. His family has a musical background, and his talents were noted at an early age. He loved to draw characters from his favorite movies and cartoons. He also developed an early interest in music, encouraged by musical family members. He started singing by age two, and by age four he was playing the piano and making up silly songs to sing.

His parents' divorce when he was nine years old may have been a pivotal point in his emotional stability. His father broke a promise he had made to Cobain when he remarried and had children with his new wife. His mother would date a man who was abusive to Cobain and his mother. He was exposed to the domestic abuse and witnessed his mother being hospitalized for injuries sustained from the boyfriend. Though the abuser broke her arm, she refused to press charges.

Teenage rebellion would hit when Cobain entered junior high. He used art and music to distract him from the problems in his daily life. His uncle offered him a guitar or a bike for his fourteenth birthday, and Cobain chose the guitar without hesitation. Before long, he could play guitar to the music he listened to and had started writing his own songs.

Along with a drummer and a bassist, Cobain started the band Nirvana in 1987. The band would take off quickly, and from the beginning, their music was popular. However, as the success grew, so did the stress associated with relationships and everyday problems that occur naturally, whether one is a rock star or a mechanic.

In 1990, Cobain met Courtney Love at a nightclub in Portland, Oregon. They were both playing for bands at the time. During their first meeting, Cobain declined Love's advances. On February 24, 1992, the couple married in Hawaii. They would have their first and only child, Frances, on August 18, 1992. The rocky relationship turned into what seemed like the happily married family life that Cobain had craved since his early childhood. However, when two musicians come together and drugs and money play an active role in their lives, mayhem follows. Sometimes even suicide and murder follow.

While Cobain struggled with emotional health, he also suffered from chronic bronchitis and intense physical pain from an undiagnosed chronic stomach condition. He first experimented with marijuana when he was only thirteen. As the years passed, he began to experiment with other drugs. He claimed to have tried almost every drug on the market. He found his drug of choice for treating his stomach pain was heroin, and he struggled with a full-fledged addiction by 1990. While it did take away the stomach pain, it caused horrible fits of vomiting and, of course, created problems in his social and professional life. He would spend some time going through withdrawals in a rehab center in 1992 but returned home and resumed the addiction.

In 1993, Cobain overdosed on heroin while playing a show in New York. However, he refused to go to the hospital and instead opted for his wife to inject him with naloxone, which pulled his body back to a conscious state. He then proceeded to finish his performance as if nothing happened. The audience knew nothing until long after the concert ended when the newspapers and local media reported the sordid details of the evening.

His first recorded suicide attempt occurred in 1994. His wife called police to report he had locked himself in a room with a gun and was threatening to kill himself. When police arrived, Kurt told a very different story. He claimed he had locked himself in the room to get away from his wife, with

whom domestic encounters were becoming a daily occurrence. In fact, Love planned an intervention in an attempt to bring a group of Cobain's friends to work together to help stop him from circling the drain with his excessive heroin use. Odd that Courtney was so concerned about her husband's drug use when she was using herself. Even odder that at the end of the intervention, he agreed to seek help.

Before entering treatment, Cobain and his best friend, Dylan Carlson, purchased a shotgun. Cobain was known to dislike guns, but he needed something to protect himself against intruders in his home. Since he had canceled a tour, he was convinced fans would be upset and possibly want to harm him or his family. He had the gun dropped off at his home before checking into rehab.

On the first day of treatment, April 1, 1994, he made several calls to his wife and talked to counselors. His stay would be short. The following night, he scaled the wall surrounding the facility and disappeared into the dark night. Taking a taxi to the airport, Cobain made his way from Los Angeles, California, to his home in Seattle.

His disappearance caused alarm, and Courtney hired a private investigator to locate Cobain. On April 4, 1994, she called the police to report Cobain as an official missing person. While people were searching, they followed the locations she suggested but didn't search Seattle until April 6, 1994. At this point, Dylan did go with the private investigator to search Cobain's home. Dylan entered alone so as not to frighten Cobain if he were home. When he returned to the car, he stated no one was home. However, they couldn't enter the home, as it was locked and fully armed. On the second visit to the house, they gained access through a kitchen window but found the home clean and empty.

On April 8, 1994, an electric company employee arrived at Cobain's Seattle home to install security lighting and made a gruesome discovery. Lying on the floor of the room above the garage was the dead body of Kurt Cobain. Detectives would discover a suicide note stabbed through the middle with a pen and a shotgun resting across his body. The cause of death was determined to be a shotgun blow to the head. Not everyone would agree with this suggestion, and many felt he had been murdered.

Why deny it was a suicide? Detectives had a note, a weapon and a man who was known to be depressed. When the toxicology reports returned, they proved the level of heroin in Cobain's blood was 1.52 milligrams per liter and there was also valium in his bloodstream. The high concentration of drugs in his system bolstered the argument that no one would have been

capable of injecting themselves with that much heroin and still have the ability to shoot themselves in the head with a shotgun.

This riddle remains a mystery to date. Visitors to Seattle still drive past Cobain's home and even leave messages on a park bench outside. His life and death would both make an impact on Seattle.

THE MERCER GIRLS

Seattle Imported Women

The Mercer family is well known and highly respected in Seattle. Three Mercer brothers played essential elements in the history of the city.

The eldest brother, Thomas, was born in Harrison County, Ohio, and stayed in his hometown until he was twenty-one. He then relocated with his parents to a farm in Illinois before deciding to venture west in 1852. With his wife and four children at his side, Thomas would lead the way as the captain of the Mercer wagon train. Unfortunately, his wife would not make it past Oregon, as a disease took her life. Thomas chose to stay in Oregon through the winter. In the spring of 1853, he was joined by Dextor Horton and William Shoudy, and they made their way north to the Washington Territory.

In 1854, Thomas claimed land and built his home near present-day Seattle. Just four years later, he was elected as the probate judge for King County and held that position for ten years. It would have been longer, but he declined reelection. He was also one of the first county commissioners.

Thomas gave English names to several lakes in Seattle, previously known under Native American names. Some of these names include Lake Washington, which was named for George Washington, and Lake Union. Later, the island in Lake Washington would be named for Thomas Mercer.

Aaron Mercer, the middle brother, traveled to Washington with Thomas. He and his wife, Ann, were the second family to settle on the shores of east Lake Washington. The swampy edge where their cabin once sat is now known as Mercer Slough.

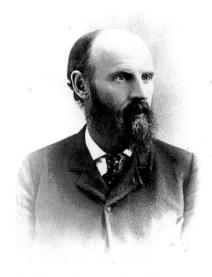

Asa Mercer, first president of the territorial university. *Seattle Public Library.*

The final and youngest of the Mercer brothers is Asa Mercer, and he left his mark on Seattle in several different ways. He assisted his brothers in clearing stumps to make way for the first territorial university. Upon completion of the university, a president and instructor were needed. Asa was the perfect candidate, as he was the only college graduate in the area at the time. This university is now known as the University of Washington.

Asa also played a role in the Johnson County War from 1889 to 1893. This series of conflicts took place in Johnson, Wyoming. The fights began when cattle companies started prosecuting suspected cow thieves. The tension began to build between the bigger companies and smaller ranches, creating several small skirmishes between the two. The larger companies hired gunmen to invade the little ranchers' lands. The small ranchers ganged up with state lawmen to make their own little posse. President Harrison sent in the cavalry to stop the two forces from fighting, but not before twenty to twenty-five men died.

The occupations of the Pacific Northwest began with several manly jobs. Men came from all over the United States to settle in Washington and begin careers in logging, fishing and mining. Men could tolerate the harsh winters, heavy rains and isolation. However, the area held little to no interest for women. In fact, early Seattle virtually lacked females. The population in Seattle included a ratio of one woman per every ten men. Young women got engaged by the age of fifteen. The only single women were the Native Americans, and there wasn't always a mutual attraction between white men and the native women. The men didn't even have a brothel or prostitutes.

The logical thing to do was bring women to the area. However, they needed a solid plan. They couldn't force women to come to Washington, and women weren't attracted to the logging and fishing jobs the area provided to suit the men. If they offered money, they would still be dealing with brothels and prostitutes. They needed to discover a way to encourage women to join them in Washington. Thankfully, Asa Mercer had some ideas up his sleeve.

Others tried to bring women to Seattle. Seattle's first brothel opened in 1861, when John Pennell arrived from San Francisco, where he had many other lucrative brothels. He built a rectangular building that had a dance floor, a bar and a few private rooms. The first prostitutes were Native American women, who didn't always appeal to the white settlers. He would later bring in women from California. However, the men in the area weren't satisfied with this temporary solution to a permanent problem.

The majority of the men agreed they had little to no interest in short-term relationships or paying for a woman's companionship. The men in Seattle were interested in long-term relationships, marriages and starting families to help increase the population of the area. Seattle would import women to the area to teach, increase the population and keep the men company on the long, cold nights in the Pacific Northwest. To do this, Mercer would take small amounts of money from the local men who wanted to meet a special girl. They purchased lotto tickets and prayed for a win.

In 1836, the lonely males of Seattle gathered funds and sent Asa to the East Coast in search of women suitable to return to Seattle. Seattle needed women, and it needed teachers. The women ranged from ages fifteen to thirty-five. They would need to travel via ship from New York to San Francisco and eventually Seattle.

A twenty-five-year-old Asa Mercer stood at a podium in Lowell, Massachusetts, telling the audience about the Washington Territory and all it had to offer. He informed them this fast-growing region was in bad need of teachers and educated ladies with decent moral standings. If the women were willing to travel with him, Mercer promised decent wages and honorable work. The women would also have housing, which had been offered by several of the more prominent citizens in Seattle.

Mercer explained Seattle's population had doubled since the first families arrived in 1851, and they had opened their first university in 1861. Massachusetts and the surrounding area had a shortage of men and jobs, thanks to the Civil War. For women of marrying age, prospects were slim if they stayed.

The trip wouldn't be free for the women, as Mercer had not been able to collect the funds he wished before leaving Seattle. Each woman would need to come up with $250 to join him and journey via train and ship. Only a small number of women could pay the fee.

In March 1864, Mercer left the area with eight women and one man as they stepped aboard the ship and began their journey to Seattle. The one man, Daniel Pearson, had fallen ill and thought a change in climate might

help. So he joined his sisters. Four women would join them along the way, to total eleven women.

The first ship of Mercer Girls, or Mercer Belles, would arrive in Seattle on May 16, 1864, very late at night. Mercer feared the people of Seattle might not be welcoming, especially due to their arrival time. Few people came to greet the women as they arrived, and they were escorted to the first and only hotel in Seattle, the Occidental Hotel.

The following afternoon, a reception was held at the university to welcome Mercer's return and the newest citizens. Of the first eleven Mercer Girls, most would teach and then marry. Two died before the turn of the decade. Elizabeth "Lizzie" Ordway was the oldest of the Mercer Girls, and she never did get married. Instead, she devoted her life to education and bringing education to the West. She first lived with the Yesler family. She then taught at Coupeville and spent the rest of her years focusing on Kitsap County. She was invited to open Central School in Seattle and later went back to Kitsap County. In 1881, she ran for the county superintendent of schools in Kitsap County and was not only elected but also reelected for the next eight years. Lizzie watched Kitsap schools grow from three districts to twenty. Dedicating her life to education and the bettering of the schools for children in our state, Lizzie left her mark as more than just a Mercer Girl.

With such success of the first expedition, Mercer started to plan his second expedition and had hopes of bringing back nearly seven hundred women. However, when he left New York on January 16, 1866, he only had thirty-four women returning to Seattle. There were many contributing factors to the decrease in numbers. Mercer faced several financial problems. He also faced some critics when he was in the East. A number of women were turned away from the prospect of jobs and marriage in the West. Several citizens in the East felt Mercer had impure intentions for these women and were convinced they were being brought to Seattle to work in brothels or be sold to men for sexual favors. They also tried to convince the women that Washington was not a favorable climate in which to live. The *New York Times* blasted Mercer for attempting to lure innocent women to Seattle for immoral purposes.

With a new spin on his business matters, Mercer planned to present his plan to President Abraham Lincoln. The Civil War had ravaged the East, leaving widows and orphans who would be perfect for a city lacking women and children. Certainly, the Washington Territory would receive government financial support.

For the second trip, Mercer planned to raise money by charging a passenger fee of $300, which would be collected from eligible bachelors. In

Central School opening day. *Seattle Public Library*.

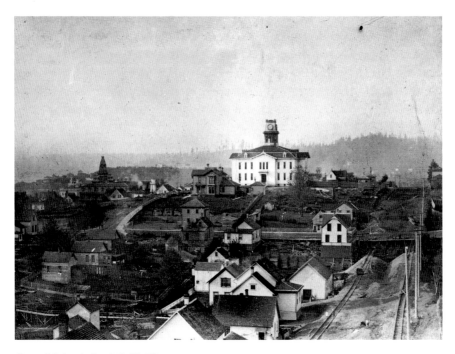

Central School. *Seattle Public Library*.

Mercer Girl Sarah Jane Gallagher Russel, 1855. *Seattle Public Library.*

Grave site of Asa Mercer. *Author's collection.*

the morning, Mercer was to present his case; Mercer learned Lincoln had been assassinated the evening before while attending the theater.

Mercer left New York with far fewer women then he had hoped and on a steamer ship. The accommodations were poor, and food was meager. During the journey, there were two births, one death and many accidents.

They arrived on May 28, 1866.

Known as an incorrigible bachelor, Asa Mercer would not be safe from the temptations of the new women. It was said that Mercer didn't give one girl fair warning when he invited her to his stateroom and confessed not only his love, but his desire to marry her, too. She laughed in his face. Records don't mention the name of the maiden in question, but legal records show Mercer did, in fact, marry a Mercer Girl, Annie Stephens, on July 15, 1866.

Seattle women weren't all schoolteachers and wife material. There were crib houses, box houses and brothels. Prostitution ran deep, and it started early. In 1853, Mary Conklin came to Seattle after her husband left her in Port Townsend. She wasted no time finding work. She managed the first inn in the city and later added a brothel upstairs. She became known as Madam Damnable.

In 1884, Washington would ban public solicitation of prostitutes. However, this would only make the brothels more popular and turn locals on to low-end theaters in which the women would serve drinks and sexual favors.

The year 1888 saw the arrival of Madam Lou Graham, born Dorothea Georgine Emile Ohben, who would build a lavish, proper brothel in what is now Pioneer Square. Unlike other brothels in the area, this one offered gentlemen an opportunity to wine and dine with business associates and enjoy some of the city's most beautiful women.

Graham herself was described as short and plump, with no great beauty about her physical features. However, she was a smart businesswoman, and it was this, paired with her air of confidence, that made her alluring.

Just four years prior to her arrival, the Washington Territory made some drastic changes. Women now had the right to vote. The city cleaned the streets of gambling and prostitution, and alcohol consumption was outlawed. This

upset some city officials, as up to this time, the payment from the owners of these businesses provided a nice source of income for Seattle. It was, in fact, their main source of income. With the city in a financial downfall, officials did what they felt would best benefit the city. They revoked women's right to vote and attempted to repair the damage they felt had followed in the wake of women voting away the vices.

Graham approached some of the leading businessmen with her proposal for a refined brothel. She sold it to them as a first-class establishment that would be filled with beautiful and intelligent women. Those wanting more than fine dining could retire upstairs, where women would offer entertainment at a price. Top businessmen were said to be nothing until they could describe the inside of Graham's brothel. For advertising, she would parade her ladies down the street in a horse-drawn carriage. Graham was proud of her occupation and never played coy. She often paraded around town with her staff to show the men of Seattle what they were missing.

Her first building, constructed of wood like everything else in Seattle, burned to the ground during the Great Seattle Fire. This didn't discourage Graham. Instead, she built a bigger and better establishment. Her new brick building stood four stories tall.

She became one of the city's wealthiest citizens, and although her life presented an image of how women were becoming stronger in the business world, her life, death and the events after her death left more questions than answers.

Graham was often accompanied by her housekeeper, Amber Delmas. Delmas had a young daughter by the name of Ulna. Both women did everything they could to protect Ulna from the sin and debauchery that took place in the daily lives of brothel owners. Graham provided a hidden, private residence for Ulna and paid for an elderly woman to be her caretaker. This would protect Ulna from not only the known vices but also unforeseen events.

For example, in 1902, Seattle police ordered every brothel to be shut down. Graham decided to take her business to San Francisco, California, which was known for playing host to all sorts of naughty establishments. Ulna would remain in Seattle with her caretaker while Graham and Delmas ventured to San Francisco to get everything set up and ready for business. Ulna and her caretaker would eventually relocate to Canada.

Within one month of arriving in California, Graham was dead. Some reports said it was a stomach ulcer caused from the great anxiety and stress in her life. Others suggested something more sinister had taken the life of this

forty-two-year-old businesswoman. They suggested everything from syphilis to a drug overdose. The unknown cause, tied into the fact that Graham died without a will, left more mysteries unsolved. Graham was a wealthy woman when she died. She had amassed a small fortune in real estate and jewelry, as well as cash. How is it possible she didn't have a will? The newspapers would report that Graham and Delmas argued in the evening before her death, and Graham's will was torn to shreds. They would also report that the original will stated all of Graham's fortune was to go to Ulna Delmas.

Two years after Graham's death, Ulna's caretaker died. Left with no apparent guardian, the young girl would find herself in a convent in Victoria, British Columbia. When a family friend of the caretaker learned of Ulna's fate and her mother's occupational choices, she proceeded to kidnap Ulna and bring her back to Seattle for safekeeping. Within a few days of returning to Seattle, Ulna was placed with a loving, caring, local family. While she didn't inherit any money, all reports indicate she went on to become a happy and successful woman and wife.

SEATTLE'S WORST MASS MURDER

Wah Mee and Capitol Hill Massacre

E ven the word massacre instills fear in people. It is defined as a specific incident involving the killing of people. The verb is known as mass killing. The first known use of the word was in 1588. Seattle would be safe for a few years, but not forever.

Underground clubs have always existed in cities and small towns. They can hide gambling, drinking and even prostitution. In many cases, they are exclusive and limited to members only.

Located in the international district of Seattle, the Wah Mee Club operated illegally in basement space on Maynard Alley South, just south of King Street. The building itself was constructed in 1909 and originally housed immigrants with hopes of striking gold or simply finding a new life in America. It began as a boardinghouse and would later become the Hudson Hotel and then the Louisa Hotel. Immigrants from China, Japan and the Philippines would stay in the hotel until they were dispatched to jobs in the area.

As far as gambling joints went, the Wah Mee Club was one of the top. In the early 1920s, it was called Blue Heaven and then in the 1980s became known as Wah Mee Club. Nevertheless, this elegant club hid in the basement of the Louisa Hotel and was only known to an exclusive list of people.

The waiters, dressed in white suits and ties, would deliver drinks as patrons danced, drank, smoked, gambled and partied the night away. Since it was an exclusive and illegal club, security was strict. Members were required to pass through a series of locked doors and be buzzed

Wah Mee Club, 1958. *Seattle Public Library.*

through to the core of the club. Those who didn't have the right to enter would be kept at bay.

For many years, this system worked. The club didn't need to hire security, because only members knew of the location and what actually went on inside the building. However, on the night of February 19, 1983, it failed. The Wah Mee Club would host an unforgettable night in Seattle's history—a night so bad that rusted padlocks would close the building from the public for many years after.

Kwan Fai "Willie" Mak was a regular at the Wah Mee Club and had lost a sizable amount of money gambling. He enlisted the help of two friends, Wai-Chiu "Tony" Ng and Benjamin Ng, to help him retrieve his lost money. Just before midnight, they entered the club without a hitch. They made it past the guards carrying semiautomatic weapons. The men were known and trusted members of the club, and therefore there was no reason to suspect the evil they had planned for the evening.

On that day, February 19, 1983, thirteen men and women were gambling inside the club. Another man was guarding the doors. As the three men

entered the core of the club, they demanded everyone drop to the floor. The robbers then hogtied their captives and robbed each person before they opened fire on the crowd. Each member of the club was shot in the head at point-blank range. The killers didn't leave the club until the morning hours.

Only one man, Wai Chin, survived. He dragged himself past the bloody mess and into the alley. Despite being shot in the throat, he escaped the building and communicated with police throughout the investigation. He later gave testimony that helped bring the murderers to justice. How did he survive? Wai Chin was the oldest and weakest of the group of members that night. He later told officials that as the executions began, he hid under a table for protection. The bullet that struck him went through his jaw, missing his brain.

After the police investigation, the doors were padlocked shut and never opened again. No one entered the building since that fateful night, and the owner refused entrance to everyone. The building remained a tomb, sealed in time. Blood, twine and markings of the crime scene were still present before the structure's demise.

Wah Mee Club, 2007. *Joe Mabel.*

What kept this building abandoned? Was it the owner's superstition or the taboo surrounding the place? We may never know, but it continued to intrigue and draw people to the story of those who were still inside. It may be that the spirits of the people who died in the building would be disrespected if it were torn down or someone else moved in. The building remained the same as it was on the night the deadly massacre took place, inside and out. Fire would eventually ravage the building, leaving investigators to wonder if it was an intentional way to get rid of the abandoned space or if it was indeed an accident.

As far as the murderers, they were also believed to be tied to other murders in Seattle. Homicide detectives described two women who had been murdered in a Beacon Hill home. The women were bound and tied up with black duct tape before being shot in the head. It's believed the killers were Benjamin Ng and Willie Mak. Benjamin was brought in for questioning but let go due to lack of evidence.

An undercover police officer was offered money to kill Benjamin by an elder in the Chinese community. For some reason, people feared him and wanted him dead. Perhaps it was because he and his friends had been traveling through the district and demanding money from the illegal clubs to offer protection.

This remains the site of the deadliest mass murder in the state of Washington, even though the building is now just a memory.

Years later, another massacre would haunt Seattle streets. Twenty-eight-year-old Kyle Huff lived in the southeast part of Seattle known as Capitol Hill.

On March 24, 2006, an event was held at the Capitol Hill Arts Center, with over 350 people in attendance, the building's capacity. Security was excellent, and only invited guests were allowed inside. During the event, Kyle was invited to the after-party at a home just down the street. As a last-minute invitee, Huff didn't know anyone at the party. He pleasantly visited with partygoers and left in a good mood, seemingly with no conflicts brewing.

He left the house and entered his truck, grabbing a shotgun, semiautomatic rifle and ammunition. Then, he spray-painted the word "now" on the sidewalk and a neighboring home's steps. He shot two people on the steps and there on the porch before reentering the home. He then opened fire on the first and second floor of the home. The entire ordeal lasted only five minutes. Thankfully, an officer was patrolling nearby and heard the shots. The officer was overcome with the bloodshed of the front porch and steps.

Moments later, he came up close and personal with Huff, but before he could do anything, Huff placed the gun in his own mouth and fired.

More weapons were located in Huff's truck, and a search warrant led to his apartment in North Seattle, where Huff lived with his identical twin brother, Kane.

The victims ranged from ages fourteen to thirty-two, both male and female. Huff's motives remain unknown, but his night of terror would become known as the worst mass killing in Seattle since the Wah Mee Club massacre.

Fifty years before the Wah Mee massacre, murder filled the streets of the International District when one man unleashed his rage. On Thanksgiving Day, November 24, 1932, thirty-year-old Marcelino Julian ran through the streets wielding a bolo knife.

Born in the Philippines, Julian immigrated to America to make money. He found work harvesting seasonal crops along the Pacific coast. He had just been released from the Pierce County Jail in Tacoma after a nine-day sentence for trapping pheasants at a hop farm near Graham. He withdrew a large sum of money from his bank and went to see his friend Tito Gualtlo, who was living at the Midway Hotel in Seattle. Within twenty-four hours of his arrival in Seattle on November 23, 1932, he would make his presence known. His plan was to stay with his friend until he could get a place of his own. Those plans would soon change.

That evening, Julian strolled down King Street and was assaulted by two African American men, who stole $200 from his shirt pocket. The following morning, he went to visit a sick relative before returning to the hotel room to find Gualtlo and his nineteen-year-old nephew Cristolo Bayada in the room. He also found that his remaining $100 was now missing. When accused of the theft, Gualtlo started eyeing the available weapons in the room, including a knife and gun. Without a second thought, Julian grabbed the bolo knife and stabbed Gualtlo in the heart, killing him. He then turned the knife on Bayada and stabbed him in the chest. Upon leaving the room, he encountered Abling Bayada, Cristolo's brother, and lunged for him, but Abling ducked into a nearby room and locked himself inside.

Julian would next encounter the hotel janitor William Tenador, who was coming down the stairs. He stabbed him in his left side. Tenador would be rushed to the hospital, only to die several hours later from the mortal wounds inflicted by the bolo knife. Julian's killing spree would not end as he exited the building. He worked his way down King Street, randomly stabbing

Bernadino Bonita in the heart before stopping by a fruit stand to use the last of his money to purchase an orange. The storekeeper, forty-six-year-old Kaneki Inyoue, would make the vital mistake of hurling an insulting name at Julian. This earned him a stab to the chest from Julian.

During the next twenty minutes, Julian continued making his way through the streets of the International District and randomly attacking unsuspecting victims, leaving a trail of death in his wake. By the end of his violent rampage, six men were killed and thirteen others violently wounded.

By this point, the calls were coming into the police headquarters. Detectives were sent to the Midway Hotel to investigate. Eyewitness reports came rolling in with details of a man and his bolo knife attacks wreaking havoc in the streets. When detectives exited the hotel, they were greeted by an angry mob armed with billiard cues, clubs and other weapons.

Off-duty patrolman Gordon Jensen spotted a man crossing King Street, wielding a large knife and acting strange. He jumped from his car and attempted to capture the suspect. Julian put up a good fight and nearly stabbed Jensen before running down an alley. The problem was that the angry mob was still in hot pursuit as well.

The mob shouted to the detectives, calling out the current location of the suspect. Officers were surprised to find Julian standing in front of a grocery store with his hands raised, as if giving up the chase. With a mob of at least twenty-five angry citizens following the officer with guns drawn, perhaps Julian saw no way of escape. Sadly, no one realized he had just stabbed the grocery store owner, who was lying on the floor with a knife wound to his right lung.

When questioned back at police headquarters, Julian claimed no recollection of the events that had just transpired and was horrified when officers explained in great detail the murder and mayhem Julian had unleashed on the city. With a simple apology, Julian clearly acknowledged no amount of money was worth the death and injury of his innocent victims.

On November 25, 1932, formal charges for the murder of Tito Gualtlo were investigated and pursued. Judge William Hoar held Julian without bail until a psychiatrist could be brought in to determine his sanity. It was determined by court-appointed Dr. Donald Nocholson that Julian was sane when he killed Gualtlo and fit to stand trial.

On December 2, 1932, he was formally charged with first-degree murder, punishable by life in prison or death. Try as he might to plead not guilty due to reasons of insanity, Julian would buy himself some time while waiting for the court to add additional psychiatric evaluations.

The trial started on April 3, 1933. A speedy trial was expected, but it took several days to select a jury of ten women and two men. There was no doubt that Julian had killed six men; however, the question of his sanity would be what sealed his fate. The prosecution would ask for a guilty verdict and the death penalty. The defense would ask for an acquittal by reason of insanity.

Late in the day on April 12, 1933, the case was delivered to the jury, which deliberated for forty-eight hours before getting stuck in a deadlock. At this point, the judge removed the issue of capital punishment, hoping this would sway the jurors to a quicker verdict delivery. A verdict came on April 14, 1933, finding Julian sane and guilty of first-degree murder. The jury voted against the death penalty in favor of life in prison at the Washington State Penitentiary.

After a mere three years in prison, Julian was transferred to Eastern State Hospital for yet another mental-health evaluation. This time the outcome would be different. The psychiatrist declared Julian certifiably insane. The judge agreed to conditional pardon, with the district understanding that Julian be deported to the Philippines. On March 29, 1936, he left Seattle.

SERIAL SEATTLE

Killers Come and Killers Go

Not only can Washington lay claim to a high number of serial killers produced in the state, but it also appears to have the highest number of victims. Oftentimes, the killer is arrested for a single murder or a low number of multiple murders. However, they will later confess to or be thought to have committed a plethora of murders, leaving a trail of victims in their wake. The case of William "Billy" Gohl is a prime example.

Billy Gohl arrived in Aberdeen, Washington, in 1902 and was suspected of killing over 130 men between 1902 and 1910. This small coastal town is located just a couple hours south of Seattle. Gohl came to Aberdeen to make money, but although the area was known to have great economic growth, it was also known to be seedy and nicknamed the Hellhole of the Pacific. The high number of loggers and sailors brought in brothels and saloons. Gohl promptly began decreasing those numbers, as he started shanghaiing, crimping and murdering for money. Shanghaiing is the act of pressing someone into service on a boat against their will. The merchant captains looked to crimps to supply the men. In other words, Gohl made a fair share of money illegally providing crews to ships entering the port. However, his motives would change, and even after marriage, Gohl would continue this occupation and begin using his rage against others to commit one murder after another.

City officials went through an elaborate process to capture Gohl. They purchased a saloon and planted informants who would provide the evidence they needed to make an arrest on February 3, 1910. Gohl was charged with

the murder of Charles Hadberg on the night of Christmas Eve. A grand jury would convict Gohl of murder based on the evidence presented, including a section of skin removed from the victim displaying three tattoos, proving the victim was dead and the body had been recovered. Gohl would spend the rest of his life at the Washington State Penitentiary.

However, it wouldn't be a long stay. His wife divorced him in 1912, and he lost not only his freedom but his health and sanity, too. Along his journey, Gohl contracted syphilis, which earned him a short stay at the mental hospital in Sedro Woolley and eventually the State Hospital at Medical Lake in Spokane. On March 3, 1927, William Gohl died from complications of syphilis, including pneumonia, erysipelas and dementia. He was only fifty-three years old.

Luis Garavito of Colombia holds the dubious title for most kills by a serial killer in the world. Garavito has 138 confirmed kills and possibly up to 300 victims. Even worse, he is known for killing, torture killing and raping children. The second and third deadliest were also from Colombia. The top two raped and murdered young children. Tenth on the list is a Washington native who confessed to killing over 71 women. He is the United States' most prolific serial killer and almost exclusively struck sex workers in the Seattle area. He is suspected of killing over 70 and convicted of killing 49. Gary Ridgway killed between 1982 and 2000 and is better known as the Green River Killer. As if holding the number ten spot wasn't bad enough, Seattle also maintains number nineteen, Ted Bundy.

Why does Seattle have two killers in the top-twenty most prolific serial killers list?

FBI profiler John Douglas called the Pacific Northwest America's killing field. This statement can be backed up by the percentage of serial killers who have lived in or hunted their victims within a two-hundred-mile radius of Seattle. What is a serial killer? Definitions vary, but the most common definition is based on the number of victims and patterns of the killings. The standard calculation is two or more victims in which the victims are unrelated and the killings are two completely separate incidents. Therefore, a murderer who kills ten victims at one time and in one location does not fit the definition of a serial killer. Oftentimes a pattern or mode of operation can be detected as well. A serial killer may choose an identical type of victim, and they may also kill in the same manner. For example, the killer may only choose young women in their

twenties or prostitutes. They also tend to have a preferred method for killing their victims.

So why does Seattle have such a bad reputation when it comes to serial killers? Some believe they are drawn to the mix of climates that cover our state. Where else can visitors experience mountains, oceans, dry and wet climates and even rainforests? Part of the problem lies with two of the most well-known killers, Ted Bundy and Gary Ridgway. These two names are synonymous with serial killings, which could be in relation to the number of victims gathered between these two men. However, they haven't worked alone to bring the number of Washington victims to an alarming tally.

Known as the Want Ad Killer and Harv the Hammer, Harvey Louis Carignan was born in Fargo, North Dakota, on May 18, 1927, to a young, single mother. The rest of his life story has been compared to an instruction manual on how to raise a serial killer. His mother rejected him. He was passed around from relative to relative until returning to his mother at age ten. He was only eleven when he spent his first stint in jail for burglary. He would stay there until he was eighteen, at which point, he joined the army and was based in Alaska.

He made his way through both Minnesota and Washington, claiming victims on the way. Carignan gained the first nickname by luring his victims to him by placing want ads in the classifieds. Harv the Hammer related to his murder weapon of choice. His killings took place between 1949 and 1974. In some accounts, his murder totals equal five, but there are countless other murders that fit the description of his killings and could very well have been victims. By all rights, he should have never been able to claim any victims in Washington, but a legal technicality made it possible. Carignan was first arrested for murder in the state of Alaska, where he took his first victim. He confessed to killing Laura Showalter by striking her in the head repeatedly with a hammer on July 31, 1949. He would first be convicted of first-degree murder, but during the appeal, his attorney would use the McNabb-Mallory rule, which states a confession is inadmissible if not properly obtained. Carignan would leave the prison free and clear.

From there, he moved on to Minnesota and was charged there with burglary and rape. He was only sentenced to two years and left early—on good behavior. This is when he made his way to Seattle and spent a few years in Walla Walla State Penitentiary for burglary. A couple of marriages and a few years later, the bodies began to appear. In 1972, two young ladies were found dead with hammer holes in their heads. A fifteen-year-old victim

answered his want ad asking for employees at a service station. When she showed up, she was raped and murdered, and her body was found months later. She was naked and her skull beaten with nickel-sized holes from the assailant's hammer. Several other bodies would turn up with the same mode of death in Washington State.

In 1974, Carignan moved his killing spree back to Minnesota. He continued to place want ads for various items to entice the women, and he continued to rape and bludgeon them with his hammer. Late in the year, both Minnesota and Washington police were not only working together but also closing in on the killer. They narrowed their search down to Carignan and, through some of his possessions, including maps and newspapers, linked him to the site of dropped bodies and the infamous want ads. It wasn't until February 1975 that he was finally tried for the attempted murder and aggravated sodomy of one of his Minnesota victims who escaped. His sloppy methods were leaving a trail of victims who were willing and able to pick him out of a police lineup.

He tried to plead not guilty due to insanity and claimed God told him to kill these women. He ended up receiving the maximum sentence in Minnesota, which was only 40 years. Will he ever be freed from prison? A passage in true-crime author Ann Rule's book *The Want-Ad Killer* implies that prisoners in Minnesota cannot serve more than 40 years. However, he was convicted of several murders and received a combined sentence of over 150 years. The 40-year maximum would put Carignan due to be released in the year 2015. But, at the parole advisory meeting, he was turned down and will not be eligible again until he turns 95 years old in the year 2022.

Robert Yates murdered at least thirteen women from the skid row district in Spokane, Washington, just east of Seattle. Most of these women were prostitutes. Yates would solicit them for sex and sometimes do drugs with them before killing them and dumping their bodies. Yates used a .25-caliber handgun to shoot his victims in the head. Two bodies were dug up from the ground outside Yates's bedroom window. These two had been shot through the heart, which indicated to the police that Yates was a marksman.

On August 1, 1998, prostitute Christine Smith managed to escape from Yates's grasp after being robbed, assaulted and shot. Police, leaning heavily in Yates's direction, requested a DNA sample, but Yates refused. Without substantial evidence, they were not able to force the sample.

However, on April 18, 2000, police had enough evidence from searching Yates's former car to make an arrest in the murder of Jennifer Joseph. The task force had been seeking the white Corvette that one of the victims described to officers as the vehicle of her attacker. With the DNA proof, the court case was open and shut. Yates was found guilty of one count of first-degree murder, but police wanted to charge him with all thirteen suspected counts. In exchange for a life sentence, rather than the death penalty, Yates accepted a plea bargain. He was sentenced to 408 years in prison.

However, in 2002, Yates would be convicted of two counts of murder in Pierce County, just south of Seattle. This time, the death penalty was sought and achieved.

Yates could file an appeal against the death penalty due to his prior plea bargain. He felt the conviction of two additional murders versus the original thirteen was unjustified. His first execution date of September 19, 2008, was put off due to the appeal trial.

In 2013, Yates's lawyers argued that he is mentally ill and suffers from a severe paraphilic disorder, which caused his craving to have intercourse with corpses. Yates's requests to appeal and overturn the death penalty have failed. Luckily for Yates, Governor Jay Inslee signed a declaration in 2013 that he would not sign death warrants for anyone while he was in office. Thus, Yates remains a prisoner on death row in Walla Walla.

Ted Bundy is one of the names most associated with the term "serial killer." In Ann Rule's book *The Stranger Beside Me*, she describes working next to Bundy in a call center and thinking he was just as normal and average as the next man. However, he had many deep dark secrets that fooled even the smartest and wittiest. Born Theodore Bundy in Burlington, Vermont, on November 24, 1946, this handsome and charismatic man would confess to over thirty murders before his death, and his true victim count may never be known, as he kept many secrets up until the very end.

He used his God-given traits to lure young women into his web. He would often employ the help of crutches or fake casts to appeal to the caring nature of some of the victims. He would then take them to a secluded area and assault them. He was known for returning to the crime scenes and visiting the decomposing bodies for sexual pleasure and grooming until they were too badly decomposed or eaten by animals. He also kept severed heads as trophies in his apartment. His first incarceration wasn't until 1975, even though his killing spree ranged from approximately 1961 to 1978. He had victims in Colorado, Utah, Florida and his home state of Washington. He

would eventually face his final conflict on January 24, 1989, when he was electrocuted in Florida.

Much like Carignan, Bundy had a rough childhood. The true identify of his father was shrouded in mystery, as his mother denied the man listed on his birth certificate was his genuine father. Bundy was brought up in the home of his maternal grandparents for the first few years of his life, and many felt his mother was actually an older sister. He and his mother moved to Tacoma, Washington, in 1950. His mother then met Johnny Bundy, who would eventually adopt Ted as his own son. While his stepfather attempted to treat him as an equal to his four new siblings, Bundy distanced himself from everyone. In high school, he was well liked and made friends easily. This would continue through college and up until the time he dropped out. At some point after this, it is believed the killings began.

In his later years, Bundy would confess many of his murders in great detail, but he refused to divulge his earliest crimes. Rumor has it that he started killing in his teens, but we will never know for sure. At age fourteen, circumstantial evidence pointed to Bundy kidnapping and killing an eight-year-old girl named Ann Marie Burr and burying her body in the foundation of Puget Sound University in Tacoma. He would deny this murder repeatedly, even up until the time of death. Her body was never recovered. Bundy admitted to his first kidnapping in 1969 but stated his first murder was not until 1971, in Seattle. Bundy told police proudly that he had mastered the art of covering up his murders.

The Seattle Police Department and King County Sheriff's Office grew concerned over the number of young college girls disappearing and turning up dead. Newspapers in Washington and Oregon were reporting the crimes and warning teenaged women in the states to be on constant high alert. The killer preferred young women with long, dark hair. The number of women hitchhikers severely decreased, as this was one of his methods for obtaining his victims. As time passed, the reports of a man in a Volkswagen Bug started to turn up as the last known vehicle the missing victims were seen entering.

King County law enforcement had enough descriptions to make drawings of the vehicle and a rough description of the killer himself. When this information was released and broadcast on television, Bundy's coworkers saw the signs. Ann Rule, Elizabeth Kloepfer and two other fellow employees would contact law enforcement to report that their clean-cut and squeaky-clean coworker matched the description of the man sought for the serial killings. In fact, police received more than two hundred reports of Ted Bundy being the killer. Officials just couldn't believe he was their suspect.

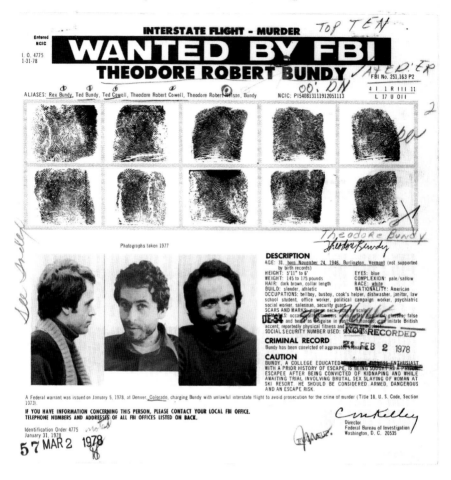

Ted Bundy's fingerprints. *FBI Digital Archives.*

Bundy moved to Utah in 1974, and this further helped keep him under the radar with the police in Seattle. By November, word of Salt Lake City murders had reached Kloepfer. A month later, Kloepfer would contact the Salt Lake City police with the same concerns. Bundy's name would be added to a list of suspects, but since there was nothing to link him to any of the crimes, he would remain a free man. As police in Washington began pulling every available resource to track the killer, they compiled a list of Volkswagen Bug owners by the name of Ted, and guess who moved up on their suspect list? This discovery was made at the time when Bundy was first arrested in Utah. A routine traffic stop led officers to the many unusual

items found in Bundy's car. These included a ski mask, pantyhose, a crowbar, handcuffs, trash bags, a coil of rope and an ice pick, as well as other burglary tools. Bundy could explain most of the items and may have slipped under the radar if the detectives hadn't remembered the description of Bundy's car being involved with the missing women reports and murders across the western United States. Sadly, they had nothing to hold him on, and he was set free. Utah police did keep him under surveillance and flew to Seattle to communicate with law enforcement there.

Bundy's first arrest came in August 1975 when he failed to stop for a traffic officer in Utah. The officer recognized Bundy's car and face from FBI wanted fliers that had been traveling around the area. With no concrete evidence to hold Bundy, they were forced to set him free. However, they placed him under a twenty-four-hour surveillance.

The first break in the case came when Bundy sold his now-famous Volkswagen. Utah police acted quickly to impound the car and turn it over to the FBI for further investigation. They matched hairs in the car with those of at least two of the victims.

Finally, in November, detectives agreed they had enough evidence against Bundy to make a formal arrest. He would go to trial on the charge of kidnapping. Law enforcement wouldn't be able to hold onto him for very long. On June 7, 1977, he was transported to the courthouse. Bundy elected to serve as his own attorney and was therefore excused from his handcuff and leg shackles. This was a grave mistake on behalf of the courts. During a recess, he hid, jumped from a second-story window and ran away to freedom on a sprained ankle. He made his way into the Aspen Mountains. Three days after his escape, he stole a car and drove back into Aspen. By this point, he had been a fugitive for six days, sleep-deprived and hurting. Police stopped him for weaving in traffic, and he was on his way back to jail, but instead of staying put, he fled once again. His escape in December wouldn't be noted for more than seventeen hours.

Bundy made his way to Florida by January and resumed his killing spree. In February, a police officer picked up Bundy for a felony stop. After all, Bundy was driving a stolen car. Little did the officer know that the motorist was on the FBI's top ten most-wanted list.

With over 250 reporters from five continents present in the courtroom, Theodore Bundy would finally stand trial for murder and face a possible death sentence. During the trial, Bundy married his Washington State Department of Emergency Services coworker Carole Ann Boone. Boone gave birth in October 1982, claiming Bundy was the father. This announcement stunned

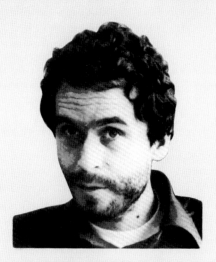

WANTED BY THE FBI
INTERSTATE FLIGHT - MURDER

THEODORE ROBERT BUNDY

DESCRIPTION

Born November 24, 1946, Burlington, Vermont (not supported by birth records); Height, 5'11" to 6'; Weight, 145 to 175 pounds; Build, slender, athletic; Hair, dark brown, collar length; Eyes, blue; Complexion, pale / sallow; Race, white; Nationality, American; Occupations, bellboy, busboy, cook's helper, dishwasher, janitor, law school student, office worker, political campaign worker, psychiatric social worker, salesman, security guard; Scars and Marks, mole on neck, scar on scalp; Social Security Number used, 533-44-4655; Remarks, occasionally stammers when upset; has worn glasses, false mustache and beard as disguise in past; left-handed; can imitate British accent; reportedly physical fitness and health enthusiast.

CRIMINAL RECORD

Bundy has been convicted of aggravated kidnaping.

CAUTION

BUNDY, A COLLEGE-EDUCATED PHYSICAL FITNESS ENTHUSIAST WITH A PRIOR HISTORY OF ESCAPE, IS BEING SOUGHT AS A PRISON ESCAPEE AFTER BEING CONVICTED OF KIDNAPING AND WHILE AWAITING TRIAL INVOLVING A BRUTAL SEX SLAYING OF A WOMAN AT A SKI RESORT. HE SHOULD BE CONSIDERED ARMED, DANGEROUS AND AN ESCAPE RISK.

FBI/DOJ

Ted Bundy wanted poster. *FBI Digital Archives.*

a crowd of people, as Bundy wasn't allowed conjugal visits. However, they would later learn Bundy had ejaculated into a condom and passed it to Boone via a kiss during a routine and very public visit.

Despite every attempt by Bundy to live a normal life while in prison and standing trial for several murders, the day would come when he was handed his sentence. Bundy would die via the electric chair in Florida. The first execution date was set for March 4, 1986, and then moved to July 2, 1986. It would move again to November 18, 1986, but Bundy would earn a stay of execution the day before his proposed death. Through the years, Bundy slowly began to detail the trail of victims he left behind in each state. The final body count reflected at least eleven victims from Washington State, eight from Utah, three from Colorado, two from Oregon, two from Idaho and one from California. Bundy would admit to killing at least thirty. However, when asked directly if his victim count of around thirty-five was accurate, Bundy stated, "Add one more digit to that, and you will have it."

On January 25, 1989, Bundy was strapped to the wooden electric chair; a black mask covered his face as the executioner filled his body with two thousand volts of electricity. At 7:16 a.m., Bundy was pronounced dead.

It was a cold, dark night and the eve of Halloween. On the night of October 30, 1947, just south of Seattle, the streets of Tacoma filled with the screams of Bertha Kludt and her teenaged daughter Beverly. An African American man broke into their home in the Hilltop area. Neighbors heard screams and called the police. Detectives would identify Bertha as the first to be chopped to death by the axe-wielding assailant. Her daughter would die while attempting to save her mother.

As police arrived at the home, they witnessed a man fleeing the house and jumping over the fence. They gave chase. The suspect reached a point where the fence was too high to climb, and he was trapped. He turned on the police officers, using a knife to attempt to fight for freedom. He stabbed one officer in the hand and another in the shoulder. A fight ensued, but ultimately the assailant was captured.

Formal charges of the first-degree murder were brought against Jake Bird on Halloween 1947 for the killing of Bertha Kludt. At that time, a suspect could only be charged for one murder when multiple deaths had taken place. So even though police knew for a fact that both members of the Kludt family were axed by the same suspect, they couldn't add the additional charges to his case.

Jury selection was a challenge, but the trial itself concluded after one and a half days of testimony. The evidence against Bird was piled high, but a surprise witness would throw a wrench in the trial. Tacoma police officer John Hickey testified that he and another officer, Russell Skattum, beat Bird while he was in custody. Both officers became aggressive after seeing the scene in the Kludt home and questioned Bird, who claimed he was not the guilty party. When they finally had Bird in custody, they were angered and unleashed on the suspect.

Bird would eventually turn over a written confession. The case reached the jury on November 26, 1947, and after thirty-five minutes, a verdict was returned. The jury found Bird guilty of first-degree murder and sentenced him to death.

On December 6, 1947, Bird was handed the formal death sentence and date of execution by Judge Hodge. He would hang on the gallows on January 16, 1948. Judge Hodge allowed Bird to address the court. It was at this time the mysteries really started. Bird gave a twenty-minute speech stating that he had been unfairly represented, and his sentence should be invalidated. He had wanted to represent himself but was denied. He also indicated that one of his own lawyers was against him and therefore not representing him properly. At the end of this speech, he clearly stated:

> *Wait and see. You policemen and judges will be settin' and waitin' at the Pearly Gates a long time before I roll up.*

This comment sparked what became known as the Jake Bird Hex, which would be blamed for taking the lives of five previously healthy men connected to the trial within one year. One month after Bird's speech, Judge Hodge had a heart attack and died. His friends and family reported that he had been in perfect health prior to the heart attack. Two days prior to Bird's execution, he was granted a stay, offering him time to continue working on his hex. The undersheriff who questioned him, Joe Karpach, died of a heart attack. The chief court clerk, Ray Scott, also died in the same month as Karpach of a heart attack. Scott had been in office for five years and never missed one day of work due to illness.

Seven months went by without a hex-related death, and the curse was nearly forgotten. Bird had appealed his case to the Supreme Court, but his conviction was upheld. Detective Lyons's attorney, the man to whom Bird made the hex threat, was the next to die from a heart attack. The defense attorney, J.W. Sheldon, was the final man to die from the hex. Sheldon had asked to be removed from the case early on, as he stated he could not

sympathize with a man who could kill in the manner as Bird. At least one prison guard who held Bird also died from a heart attack, bringing the final hex deaths up to a count of six.

After many appeals, Bird would eat his last meal on July 14, 1949. He was shaved and dressed in new clothes as they moved him to a cell closer to the gallows. Fourteen minutes after being hanged on the gallows on July 15, 1949, Bird was pronounced dead.

While many haven't heard of this case, Bird claims to have killed at least forty-four people, thus making the man from Tacoma, just south of Seattle, one of the world's most prolific serial killers. He is also the first serial killer to use a hex as a murder weapon.

Born to a New York prostitute, Kenneth Bianchi wasn't a Seattle native, but he did kill in Washington and would spend the remaining years of his life at Walla Walla State Penitentiary. Bianchi, better known as the Hillside Strangler, raped, killed and kidnapped women ranging from age twelve to twenty-eight and from all walks of life. He worked with a partner by the name of Angelo Buono. Together the two posed as undercover police officers to lure in their victims. Bianchi even applied for a position with the Los Angeles Police Department and did a ride-along with officers searching for the Hillside Strangler.

Bianchi moved to Bellingham, Washington, shortly after the two made drastic mistakes on their eleventh murder and a fight erupted between him and Buono. After admitting to Buono that he had ridden along on police rides and was helping to solve the Hillside Strangler cases, Buono broke into a violent rage and threatened to kill Bianchi if he didn't move.

On January 11, 1979, Bianchi was working as a security guard when he lured two female Western Washington students into a house he was guarding. Without help from his partner, Bianchi had trouble subduing both women at once and made many mistakes, including leaving traceable clues behind at the scene. His arrest soon followed.

Like others before him, he entered a plea of not guilty by reason of insanity. The police psychiatrist would prove Bianchi had been trying to falsify his mental state. However, he was eventually diagnosed with antisocial personality disorder and sexual sadism. Testifying against his previous partner, Angelo Buono, would help Bianchi secure a more lenient sentence at his trial. He got comfortable at his new home, the Walla Walla State Penitentiary.

Gordon Coe and his wife, Ruth, lived in the upscale neighborhood of South Hill, located just four hours east of Seattle in the city of Spokane, Washington. Ruth worked as a teacher at a local charm school while her husband spent his days as a newspaperman. Gordon held the title of the editor-in-chief for the *Spokane Daily Chronicle* for twenty-six years.

The *Daily Chronicle*, along with another local newspaper, began publishing stories about a rapist in the South Hill area targeting joggers. Items like mace and handguns were flying off the racks. Gordon made sure to keep the articles on the rapist low-key, as he was wanting to help bring people to Spokane, rather than scare them away. Other media were not being so conservative.

The action started on April 26, 1978: a nineteen-year-old woman had a quarrel with her husband at a restaurant and decided to walk home alone. Her night was about to take a turn for the worse. She was raped just after midnight. Her assailant forced his fist in her mouth to muffle her shouts for help. This was the first of a brutally high number of rapes in Spokane over the next two years.

The rapes began to take on common characteristics. Each victim reported the man placed his fist, often covered with a glove, in her mouth. Their assailant talked to them and asked them personal questions during the act. They were all threatened that he would kill them if they told the police, and he was sure to mention that he knew where they lived before he disappeared.

On August 30, 1980, a fifteen-year-old girl took a bus home from a rock concert and was raped just after midnight.

On October 23, 1980, a twenty-seven-year-old female was heading home from work via bus and raped around 6:30 p.m.

On December 17, 1980, while walking home from a friend's house, a fourteen-year-old girl was raped. As the rapes stacked up in number, police began to wonder if they were dealing with three or four individuals committing the crimes. Even the *Spokane Daily Chronicle* reported the rapes, but under the calming pen of Gordon Coe, the newspaper attempted to keep the people of Spokane and South Hill from going into a panic mode.

On February 5, 1981, a fifty-one-year-old woman was jogging and raped at 7:00 a.m. By this point, the panic rested like a fog over the small city of Spokane. The normally peaceful atmosphere had died. The following day, a janitor from the local school would tip police that he had seen a silver Chevy Citation like the one linked to the crime in the area on the previous morning. This information would prove beneficial: the car was registered to Gordon Coe.

On February 9, 1981, a twenty-year-old woman dropped her son off at her mother's house and was raped just three houses away.

Just days later, enough evidence had been gathered to place Coe under police supervision.

By March 4, 1981, the Spokane Police Department announced that their task force had spent over eight thousand man hours tracking the South Hill Rapist.

Four days later, an eighteen-year-old girl said she was confronted by a man while running. While she was unable to clearly identify the man, others in the area did take down the license plate on his car.

On March 10, 1981, police had their main suspect in mind from the evidence gathered on the incident on February 5, 1981. When police arrested Frederick Coe, Gordon's son, other victims were called in, and several identified him as their attacker. Five additional rape charges were added to the case against Coe. Coe pleaded not guilty and was released on a $35,000 bond.

Gordon Coe was forced to take a leave of absence and then formally retired in October of that year. It was too much publicity for a newspaper editor to make the headlines himself.

The first indicator of strange behavior from the Coe family came in a July 1981 *Seattle Times* article. During the interview, Coe maintained his innocence and mentioned that he and his mother had been privately working the case in an attempt to catch the South Hill Rapist. Coe claimed this entire arrest was based on mistaken identity. His mother claimed that she and her son had gone out several times to search for the rapist. At times, her son dressed as a jogger, and she followed behind him in her car. This was her explanation for why their car was always close during the rapes.

When a jury was chosen, Spokane found the case hit too close to home, and it was moved to Seattle, where an impartial jury could be selected. The trial would start in Spokane with a jury full of Seattle citizens. When Coe himself took the stand, he told the court of his innocence and insisted he had an alibi for every rape. His mother testified that he was with her during each of the six rapes. His father did as well, stating he was indeed at home with them.

Just nine days after the trial began, the jury convicted Coe on four counts of rape and acquitted him on two. The prosecutor stated that he was convinced Coe was responsible for at least twenty additional rapes but doubted that further convictions would follow. The judge sentenced Coe to life plus seventy-five years and denied the defense's request to commit Coe

to a mental institution. Even after an appeal to the Supreme Court, Coe's request to be committed failed.

In 1982, Frederick Coe changed his name to Kevin Coe. However, his name would remain synonymous with the South Hill Rapist for the years to follow.

The mayhem continued when Ruth Coe decided to plot a little revenge on the judge who presided over her son's case. The publicity from the case and loss of her son took a toll on Ruth, who was diagnosed with bipolar disorder. While at a function with friends, she overheard a joke about the mafia, and this sparked her interest. She decided to hire a hit man to kill Judge George Shields and the prosecuting attorney, Donald Brockett. This loving mother, who would do anything for her children, agreed to pay $4,000 to the hit man and even paid $500 down as a deposit. Unfortunately for her, she made the deal with an undercover police officer. The entire conversation was taped.

Judge Robert Bibb presided over Ruth's trial and found her guilty. Ruth served a short time in jail and then was granted a work release. The judge suggested it was a sentence from the heart rather than the head. She would continue to watch her son fight for his freedom over the years.

In 1983, Coe's case went to the Supreme Court, and four first-degree rape charges were overturned due to three of the victims being hypnotized prior to identifying Coe. Before the end of 1984, a judge would rule the hypnotized victims were allowed to testify at the trial.

Coe's second trial began in Seattle in 1985 and continued until 1988. Due to the hypnotizing, the convictions were retracted as soon as they were placed, and this process continued. By 2006, Coe was scheduled to be released from Walla Walla State Penitentiary. After all, he was only convicted of one rape by the time the trials ended. He was sentenced to a mere twenty-five years in prison.

In 1990, Washington State passed a community protection act that would allow the state to indefinitely retain dangerous sexual predators and violent offenders. If an offender is found to possess a mental defect that makes them more likely to offend, they can be held beyond their sentence.

The courts tried to apply this statute to Coe in 2007, but the judgment would be postponed until 2008. New evidence was located in boxes of police evidence. A rape kit slide with DNA linked Coe to the one rape for which he was convicted. Unfortunately, there was no DNA evidence convicting Coe of the three overturned cases. Upon completion of his twenty-five-year prison sentence, Coe was sent to McNeil Island, where he is civilly confined.

David Rice followed a right-wing extremist group called the Duck Club. On Christmas Eve 1985, he broke into the home of a civil litigation attorney by the name of Charles Goldmark. Rice mistakenly believed that Goldmark and his family were Jewish and communists, both of which his group disliked.

Upon arriving at the Goldmark home, a small boy answered the door. Rice wasn't expecting this, as he thought only Charles and his wife would be at the home. Rice explained that he had a package to deliver to Charles Goldmark, and the young boy called his father to the door. Rice then used a toy gun to force his way into the home. The boy ran to the kitchen as Rice held Goldmark to the ground and kicked the front door closed.

Rice demanded Goldmark call his son back into the room and then forced the two males upstairs to the bathroom, where Goldmark's wife was showering. While Charles called his wife, Annie, from the shower, a second male child came into the room to see what all the noise was about. The entire family was forced to the floor, and Goldmark was handcuffed to his wife. Rice poured chloroform on a rag and placed it to the nose of each Goldmark family member; they instantly lost consciousness. He then headed downstairs to find a weapon.

Rice hoped to find a meat cleaver but settled for a filet knife and a clothing iron to use for beating his victims. Upon returning to the master bedroom, Rice first struck Goldmark on the back of his head four to five times before doing the same to Annie. He then repeated this action with the two small boys. Annie died instantly, and the three remaining family members hung on to life by a thread.

Rice made his escape. He walked two miles to his home and then remembered that he had forgotten to remove the handcuffs. He continued home to change out of the blood-splattered threads and then returned to the Goldmark home. By the time he arrived, the victims had already been discovered, and police sirens cut through the air.

One son died on December 28, 1985. Charles died on January 9, 1986, and the second son passed on January 30, 1986. The entire Goldmark family was dead. Luckily, the mistake of leaving the handcuffs left Rice's fingerprints at the scene.

Rice's trial began in May 1986, and one short month later, the jury took less than five hours to find him guilty of four counts of first-degree murder. While the jury agreed Rice should receive the death penalty, this was overturned by the judge. Rice would eventually plead guilty, avoiding the death penalty. He was sentenced to life in prison without the possibility of parole.

When mentioning serial killers, it only makes sense to end this chapter and this book with Gary Ridgway, the Green River Killer. Ridgway was born in Utah with his two brothers. Like other serial killers, his home life as a child was troubled at best. His parents frequently fought in front of the children. He was a bed wetter until the age of fourteen, and his mother would force him to strip down to nothing and then bathe him. This caused a mix of strange new feelings for a young and curious boy.

He graduated from high school at age twenty and married his high school girlfriend, Claudia Kraig. He would not stick around for very long. He joined the navy and was deployed to Vietnam, where he saw combat from the supply ship on which he worked. It was during this time that he began having sexual intercourse with prostitutes and contracted gonorrhea. While in Vietnam, his wife started an extramarital affair, and their marriage ended within the year.

After his homecoming from Vietnam, Ridgway married again, but again it would end with his wife cheating on him and him soliciting prostitutes for sex. Ridgway was said to have an insatiable sexual appetite and demanded sex from the women in his life multiple times per day. He especially enjoyed rough sex in public locations.

The bodies began to stack up along the Green River. The first one to be discovered was on July 15, 1982, found by children playing near Kent. Police found a strangled female body that was later identified as sixteen-year-old Wendy Coffield.

By August 16, 1982, four additional bodies were found in or near the Green River. This is when police decided it was time to start up the biggest task force since the one established for Ted Bundy. The King County Sheriff's Department organized the Green River Task Force to investigate the high number of murders leaving a trail of victims along the banks of the Green River. They joined forces with leading experts on the inner mind of serial killers. Their most notable experts included Ted Bundy, who himself currently held the title of most victims in Washington State. The task force also had Robert Keppel, who began his career as a homicide detective. Keppel went on to become the chief criminal investigator for the Washington State attorney general's office. He would then turn to teaching others his well-honed skills for catching serial killers by becoming a professor of criminal justice. Bundy and Keppel had a connection with Thomas Harris, author of *The Silence of the Lambs*: Bundy's Florida trial assisted him in writing sections of the book. Harris also told Bundy that the relationship between the main characters, Clarice Starling and Hannibal Lecter, was inspired by the relationship Keppel

had with Bundy. Another task force member, Dave Reichert, currently serves as a representative for Washington's Eighth Congressional District. Prior to that, he was the sheriff of King County. Reichert played an important role in the task force and bringing Ridgway to justice.

The first connection to Ridgway was a tip that came in on April 30, 1983, when victim Marie Malvar disappeared. Malvar's boyfriend followed the truck he believed belonged to the person responsible for his girlfriend's death. The truck was identified as one belonging to Ridgway.

In 1984, the death toll was up to over forty women, ranging in ages from fifteen to thirty-one. Several victims described a truck matching the one Ridgway drove, and he lived in the area near where the murders were taking place. He was offered a polygraph test and agreed to take it, but this offered detectives no leads. Ridgway passed the polygraph test with no problems. He admitted to soliciting prostitutes but nothing more. He played the part of a nice, married, family man who worked hard at his job and occasionally played at night by hiring a prostitute to entertain his sexual needs.

The bodies continued to pile up, and they all had traits in common. Most were prostitutes, and their disappearances were not immediately reported. All victims were strangled to death. Armed with a search warrant, the task force entered Ridgway's home in 1987. They removed carpet fibers, ropes and plastic wrap. None of these samples matched up with those found on the victims.

By 1992, the case was drawing cold and the task force had been cut down to one single officer. That officer was Todd Jensen. By this point, the advances in DNA testing had drastically improved, but Jensen wasn't sure it was good enough and worried about wasting the few remaining samples by putting them through additional testing. He wouldn't send the samples again until 2001. He was pleased to see there was a match to the semen found on several victims. It corresponded with the saliva samples they had obtained from Ridgway. Police had their killer.

With an end in sight, the task force came back to life and reassembled. Ridgway went under twenty-four-hour surveillance, and two months later, they caught him soliciting a prostitute, an undercover police officer. He was arrested on November 30, 2001, for murder and agreed to plead guilty to forty-eight killings and direct investigators to the remains of the victims. Police were hopeful this would bring peace to the family members, who were eager to know the locations of their loved ones. The plea bargain would also save Ridgway from the death penalty.

At least four detectives spent several hundred hours questioning Ridgway. They honored all of his strange requests, including salmon and specific reading material. Ridgway offered information on the killings in exchange for these special requests.

On December 18, 2003, Gary Ridgway was sentenced by Judge Richard Jones of the King County Superior Court. He would receive forty-eight life sentences with no possibility of parole. He received one more life sentence and an additional 10 years for tampering with evidence on each of the forty-eight victims. This brought his total sentencing to forty-eight life sentences and 480 years. Ridgway would never be allowed to roam free ever again.

After the conviction, he did as he promised and led police to more bodies. In fact, Ridgway confessed to more murders than any convicted American. In his confessional tapes, he explained that prostitutes were easy targets and weren't missed. He professed a hatred toward them and admitted to having sex with the victims after he had killed them via strangulation.

He started his prison life in solitary confinement at Walla Walla State Penitentiary but would eventually be transferred to a high-security prison in Colorado. The downside to this transfer was that Ridgway was no longer easily accessible to the team that was still attempting to solve murders associated with the Green River Killer case. Ridgway returned to Washington in November 2015 and remains just east of Seattle at the state penitentiary.

Next time you hear a bump in the night, keep in mind, people like Gary Ridgway, David Rice, Kevin Coe, Robert Yates and many other convicted murderers are separated from society by steel bars, but they are alive and in Washington State. This motley crew is no longer committing murder or creating mayhem in the city of Seattle, but that doesn't mean they aren't creating nightmares in the minds of innocent men and women fearing the ultimate sin: murder.

Those mentioned in this book are only a few of the mysterious characters who have left their mark on history by creating mayhem and having a penchant for murder in or around the sometimes ominous city of Seattle, Washington.

BIBLIOGRAPHY

"About the Seattle Municipal Archives." http://www.seattle.gov/cityarchives.

Allison, Ross, and Teresa Nordheim. *Tacoma's Haunted History*. Charleston, SC: Arcadia Publishing, 2014.

Andrews, Mildred Tanner. *Seattle Women: A Legacy of Community Development*. Seattle: YWCA of Seattle/King County, 1984.

———. *Woman's Place: A Guide to Seattle and King County History*. Seattle: Gemil, 1994.

Andrews, Mildred Tanner, Leonard Garfield, Karin Murr Link, Marc K. Blackburn and Dana Cox. *Pioneer Square: Seattle's Oldest Neighborhood*. Seattle: Pioneer Square Community Association, University of Washington, 2005.

Austin, Charles W., and H.S. Scott. *The Great Seattle Fire of June 6th, 1889: Containing a Succinct and Complete Account of the Greatest Conflagration on the Pacific Coast*. Seattle: Shorey Book Store, 1966.

Baurick, Tristan. "Olalla's Starvation Heights Still Causes Chills after a Century." *Kitsap Sun*, December 30, 2014.

Bayley, Christopher T. *Seattle Justice: The Rise and Fall of the Police Payoff System in Seattle*. Seattle: Sasquatch Books, 2015.

Berner, Richard C. *Seattle 1900–1920: From Boomtown, Urban Turbulence, to Restoration*. Seattle: Charles Press, 1991.

Bragg, L.E. *More than Petticoats: Remarkable Washington Women*. Helena, MT: Twodot, 1998.

Buerge, David M., and Stuart R. Grover. *Seattle in the 1880s*. Seattle: Historical Society of Seattle and King County, 1986.

Burke, Edward, and Elizabeth Burke. *Seattle's Other History: Our Asian-American Heritage*. Seattle: Profanity Hill Press, 1979.

Denny, Arthur Armstrong, and Alice Harriman. *Pioneer Days on Puget Sound*. Seattle: Alice Harriman Company, 1908.

Easley, Taylor. "Berry Lawson's Death and African American Civil Rights in 1930s Seattle." http://depts.washington.edu/depress/berry_lawson.shtml.

Evans, Jack R. *Little History of Pike Place Market, Seattle, Washington*. Seattle: SCW Publications, 1991.

Furtwangler, Albert, and Chief Seattle. *Answering Chief Seattle*. Seattle: University of Washington Press, 1997.

Gardner, James Ross. "Exquisite Corpses." *Seattle Met*. March 23, 2012.

"Gary Ridgway Biography." Accessed February 10, 2016. http://www.biography.com/people/gary-ridgway-10073409.

Goss, Heather Vale. *Crimes & Capers of the Northwest*. Edmonton: Folklore Publishing, 2010.

Hershman, Marc, Susan Heikkala and Caroline Tobin. *Seattle's Waterfront: A Walker's Guide to the History of Elliott Bay*. Seattle: Waterfront Awareness, 1981.

HistoryLink, s.v. "The Mahoney Trunk Murder Occurs on April 16, 1921." Accessed February 14. 2016. http://www.historylink.org/index.cfm?DisplayPage=output.cfm&file_id=7285.

———. "Police Capture Serial Killer Jake Bird after He Murders Two Tacoma Women on October 30, 1947." Accessed March 4, 2016. http://www.historylink.org/index.cfm?DisplayPage=output.cfm&file_id=7971.

———. "Spokane's South Hill Rapist: The Kevin Coe Case." Accessed May 1, 2016. http://www.historylink.org/index.cfm?DisplayPage=output.cfm&file_id=9484.

———. "Wappenstein, Charles W." Accessed April 27, 2016. http://www.historylink.org/index.cfm?DisplayPage=output.cfm&file_id=8904.

"In Memoriam." Accessed January 5, 2016. http://www.seattle.gov/police/recognition/memoriam/memoriam3.htm.

Jones, Nard. *Seattle*. Garden City, NY: Doubleday, 1972.

Keppel, Robert D., William J. Birnes and Ann Rule. *The Riverman: Ted Bundy and I Hunt for the Green River Killer*. New York: Pocket Books, 1995.

Kluger, Richard. *The Bitter Waters of Medicine Creek: A Tragic Clash between White and Native America*. New York: Alfred A. Knopf, 2011.

Morgan, Murray. *Skid Road: An Informal Portrait of Seattle*. Seattle: University of Washington Press, 1982.

Murderpedia, s.v. "Harvey Carignan." Accessed February 14, 2016. http://murderpedia.org/male.C/c/carignan-harvey.htm.

———. "Jake Bird." Accessed May 9, 2016. http://murderpedia.org/male.B/b/bird-jake.htm.

———. "Randolph G. Roth." Accessed January 12, 2016. http://murderpedia.org/male.R/r/roth-randy.htm.

———. "Robert Lee Yates Jr." Accessed March 10, 2016. http://murderpedia.org/male.Y/y/yates-robert-lee.htm.

———. "Theodore Robert Bundy." Accessed February 3, 2016. http://murderpedia.org/male.B/b1/bundy-ted.htm.

Olsen, Gregg. *Starvation Heights: The True Story of an American Doctor and the Murder of a British Heiress*. New York: Warner Books, 1997.

Osborn, Andrew. "Face Down in the Wishkah." Undergraduate thesis, University of Washington, 2013. http://digitalcommons.tacoma.uw.edu/history_theses/3.

Roe, JoAnn. *Seattle Uncovered*. Plano, TX: Seaside Press, 1996.

Rule, Ann. *Green River, Running Red: The Real Story of the Green River Killer, America's Deadliest Serial Murderer*. New York: Free Press, 2004.

———. *The Stranger Beside Me*. New York: Norton, 2000.

Schmid, David. *Natural Born Celebrities: Serial Killers in American Culture*. Chicago: University of Chicago Press, 2005.

Speidel, Bill. *Doc Maynard: The Man Who Invented Seattle*. Seattle: Nettle Creek Publishing Company, 1978.

———. *Through the Eye of the Needle*. Seattle: Nettle Creek Publishing Company, 1989.

Stack, Andy [Ann Rule]. *The Want-Ad Killer*. New York: Signet, 1988.

"Ted Bundy Biography." Accessed May 17, 2016. http://www.biography.com/people/ted-bundy-9231165.

Warren, James R. *The Day Seattle Burned: June 4, 1989*. Seattle: J.R. Warren, 1989.

Warren, James R., and Mary-Thadia D'Hondt. *King County and Its Queen City, Seattle: An Illustrated History*. Woodland Hills, CA: Windsor Publications, 1981.

Williams, David B. *Too High and Too Steep: Reshaping Seattle's Topography*. Seattle: University of Washington Press, 2015.

INDEX

ABOUT THE AUTHOR

Teresa Nordheim is an award-winning author with over forty published articles to her credit. This mother, nurse and researcher gets her inspiration from such authors as William Shakespeare, Edgar Allan Poe and Isaac Asimov. She is also a freelance writer and illustrator and an avid paranormal investigator and director of research for AGHOST (Advanced Ghost Hunters of Seattle Tacoma).

Visit us at
www.historypress.net

···

This title is also available as an e-book